DANCERS
IN MOTION

The Art and Technique of Dance Photography

Susan Michal
M.Photog.Hon.Mphotog.Cr.,CPP,ABIF-ASP

Amherst Media, Inc. ■ Buffalo, NY

CW01033133

Susan Michal is an internationally published, award winning portrait artist. Her adorable and unique photographic images have been used in calendars, greeting cards and posters around the world. She is a respected lecturer both in her community and within professional photographic associations. Susan holds the Master Craftsman Degree in photography and is certified by the Professional Photographers of America. She is an ASP fellow, one of only nineteen women to hold this distinction from the American Society of Photographers. She has been named North Florida's photographer of the year and is an active member of Professional Photographer's of North Florida and Professional Photographer's of America. She has won numerous awards including Best of Show at Southeast Professional Photographer's. Susan is a past president of Professional Photographer's of America and is a member of the Society of Twenty Five.

Published by:
Amherst Media, Inc., P.O. Box 538, Buffalo, N.Y. 14213
www.AmherstMedia.com

Publisher: Craig Alesse
Senior Editor/Production Manager: Michelle Perkins
Editors: Barbara A. Lynch-Johnt and Beth Alesse
Acquisitions Editor: Harvey Goldstein
Associate Publisher: Kate Neaverth
Editorial Assistance from: Ray Bakos, Rebecca Rudell, Jen Sexton
Business Manager: Adam Richards

ISBN-13: 978-1-68203-204-6
Library of Congress Control Number: 2016952108
Printed in The United States of America.
10 9 8 7 6 5 4 3 2 1

www.facebook.com/AmherstMediaInc / www.youtube.com/AmherstMedia / www.twitter.com/AmherstMedia

CONTENTS

The Author. 2

Introduction . 5
My Equipment. .6

The Dancer . 7
Dancing Is All About the Feet. 8
Dance Chooses You .9

The Basics . 10
Understand How to Communicate.10
Many Business Opportunities10
Gymnastics .11
Learn as Much as You Can12
Be Prepared and Confident12
Technical Knowledge and Artistic Vision12
A Camera Made for Capturing Sports.12

Working Together 14
Dancer and Photographer: Artists at Work14
Prepare, Preplan, and Be Ready to Instruct15
Be Aware of How Long a Dancer
 Can Give 100 Percent .16
The Dancer's Need to End the Session17
A Dancer's Strengths and Weaknesses18
Have Realistic Expectations.18
Speak to Dancers, Learn their Vocabulary20
Control the Session by Communicating20
Expectations .21
Start an Image Folder .22
Two Sets of Terminology. .22
Know Basic Positions .23
Terms Help to Communicate Simply.24

Setup and Posing 26
What Makes a Perfect Photograph?26
Direct and Refine .26
Reposition and Rethink. .28
Let Them Try, Then Move On28
Avoid Unflattering Positions31
Appropriate Posing. .31
Position the Dancer for Your Chosen Line,
 Angles, and Shapes .32
A Movement Pose Is Better33

Dance School Subjects. 35
Comfortable Subjects. .35
Work with Instructors. .35
Advantages to Work with the Experienced.36
Start with the Feet .37
Plan and Organize for Schools38
Give Parents Image Choices39
Use Props, But Do the Math40
Keep Your Equipment Consistent40
Designate a Set for Groups42
Advanced Dancers at Dance School.43
Very Young Dancers . 44

Young Dancers. 45
A Big Seller . 45
Instructors to Help with Younger Dancers 46
A Non-Negotiable Rule . 47
A Typical Set of Poses . 48
The Curtain Call . 49

Poses for Different Levels. 50
Pre K and Kindergarten Ballet Poses50
Pre K and Kindergarten Jazz and Tap Poses51
Intermediate Ballet Poses52
Intermediate Jazz and Tap Poses53
Advanced Ballet Poses .54
Advanced, Tap and Jazz Posses.55

Special Needs. 56
Children with Special Needs Thrive57
Recognize Their Particular Needs57

Capturing the Significant 58
Using Sets .58
Suggest Motion with Posing Technique59
The Ultimate Goal: Dance Movement60
A Flowing Skirt Indicates Apparent Motion60
The Image Is Worth the Effort61
Show an Example .61
Too Many Ideas Can Cause Confusion62
Too Much Input Can Confuse63
Be On the Same Page as Instructors63
A Neutral Background Frames the Subject64
Just Let the Magic Happen65
Find the Dancer's Rhythm66

Photographing Leaps 67
Dynamic and Challenging 67
Timing is Everything—Count 68
Capture Leaps in the First Few Attempts 69
Recognize Ability . 69
Pay Attention to the Details 70
They Will Try the Leaps 70
Time for A Classic Portrait 70

Space, Backdrops, and Safety . . . 72
Size of Work Space . 72
A Good Space for Photographing73
Canvas Backdrops .73
Safe Floors for Dancers73
Safety Should Come First74
Keep Floors Clean .74

Lighting . 75
Lighting Makes or Breaks the Image75
Situations Determine Your Choices77
Flash and Flash Duration77
Light and Stopping Action79
A Complete Light Set .79
Number of Lighting Stations80
Make Lighting Stations Identical80
Use Forgiving Lighting80
Start with One Lighting Kit81
Dance School Lighting Setup81
Kits That Produce Studio Lighting82
Many Good Lighting Choices82
A Softbox with Reflector for Fill83
At Times Use A Grid .83
Dramatic Lighting .85
With Dramatic Lighting, Shoot RAW85
Keep Dancers on the Background85
Position Is Critical .86
Advanced Dance Lighting Setup87
Using Umbrellas .87

Shooting Live Performances 88
Shooting Live .88
Use a Monopod .88
Preferred Camera Settings89
Keep Feet Sharp .90
See the Moment Coming90
Camera Position .91
Anticipate the Decisive Moment92

High School Senior Dancers 93
Senior Pictures on Location93
Dance School Feeds into Senior Pictures93
Provide Unique Ideas .94

Provide Different Session Locations94
Take Care of Your Subjects95
Backlight for Silhouettes95

Male Dancers96
Few and Far Between .96
Power and Strength .96
Direct and Encourage .97
Clothing Alternative .97
Be Reassuring .98
A Better Performance .99
Change to Dramatic Lighting 100
Dance Through Poses101
Post-Production . 102
Getting Lucky with Images 102
Understanding the Dancer 103

Things to Keep in Mind 104
Peer Pressure and Assurance 105
Body Image Issues . 105
Choose Poses that Work Well
 with the Costume and Dancer 106
Dancers Should Understand Light107
Direct Within the Light107
Understand Your Depth of Field 108
Natural Light for a Different Look 109
A Fast Shutter to Stop the Action 109
Relationships Build .110
Try Something New .111
Get Outside of the Box111
Seriously Hard to Do .113

Dance Partners 113
Two Properly Lit Dancers113
Photographing Partners115
Different Kinds of Lifts116
Finding Dancers to Work with You116

Collaboration and Beyond 118
Document the Amazing118
The Professional and the Creative120
Try Different Lighting Techniques120
Consider Working with Gymnasts122
A Conversation .123
An Unusual Place: Salt Flats124
The Enduring Dance Vocation,
 Documented .124

Thanks . 126

Index . 127

INTRODUCTION

Doing something you love for a living is a tremendous gift. I have been fortunate to support myself as an artist my entire life, first as a professional musician and then as a photographer. I am in awe of all it has allowed me to do. I am grateful, and I get to touch others lives as deeply as they have touched mine by allowing me to photograph them. Never take for granted the gifts you have been given.

I first started photographing dancers nearly fifteen years ago. A studio client owned a dance school and asked me if I would be willing to photograph the school—more than 275 children—and I was bitten by the dance bug. (I mean, what is more beautiful than a four-year-old in a tutu:) After a twenty-year career in the music business, photographing dancers was a natural fit for me. I used every opportunity to learn more and, in time, I was asked to photograph advanced and professional dancers.

Photographing a dance school is similar to the volume photography of an academic school with regard to post-production and organization, but is very different in an artistic view. Dance schools can provide a good income for a set part of the year. It would be ideal if this stream of revenue could be spread out, but most want to be photographed right before recital season—March through mid-June—requiring you to be on top of your competitive game. Photographing dance schools provides a never-ending channel for new studio business. You can expect families, children, and seniors.

In this book, I will share with you how I work with my dance schools and more advanced dancers. I have focused on information about photographing dancers and left the business side of operations for another book.

Although, I consider myself a natural-light shooter, I prefer to use studio lighting using a classic style background because this emphasizes the lines of a dancer's body. Occasionally, I do enjoy working in an old warehouse or cool location, especially if it is part of a senior session. I have done underwater photography with dancers–now that's a challenge! Whatever the situation, I love to photograph a dancer. Truthfully, I am a by-the-seat-of-my-pants kind of girl! I like to change things up, and I am not afraid to try something new. The only way this can be done successfully is by managing your equipment skillfully

Visit Susan Michal at:
 EandSProductions.com
 SusanMichalPhotography.com
 SusanMichalFineArt.com
Or contact at:
 studio@susanmichal.com
 904-262–8892

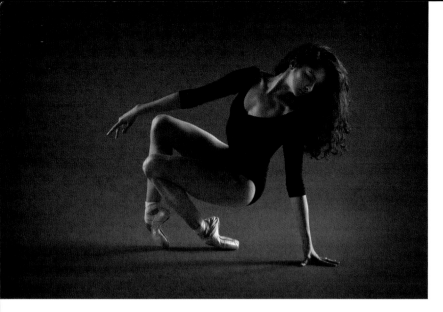

My Equipment

I use Canon cameras. My favorite camera is a top of the line sports camera. I usually buy them the minute they hit the streets because I always want the best and the fastest. Most of the images in this book were taken with the Canon EOS-1D X camera. For dance school assignments, I use a Canon 24–105 lens. When working with advanced dancers I prefer my EF 70–200mm f/4L if I have enough room. It's much lighter than my favorite lens, it's heavy brother the EF 70–200mm f/2.8L.

In the studio I shoot at f/5.6, and though shutter speed is irrelevant, I usually have it set at $^1/_{125}$ of second. When outside my favorite settings are f/4 to f/5.6 with at least a $^1/_{500}$th shutter speed. I will use whatever ISO I need to get to those settings. As it gets darker, I will change the aperture before I change my shutter speed.

For dance school assignments, I use a foldable 4x6-foot softbox from Denny Manufacturing and two large strip boxes. I use honeycomb grids, in most situations and add a hair light when ceiling space allows for it. I add a large white Lastolite reflector to bounce light into the shadows.

When working with advanced and professional dancers, I prefer a bit more dramatic lighting, but still want to give the dancers a little room to move. I use two 86-inch soft silver umbrellas with two large strip boxes for accent lighting. I will move these lights around if needed.

I prefer a 12-foot canvas backdrop when possible and love my David Mahue backgrounds. The one featured most in the images of this book is called Sand.

I hate using a tripod when working with dancers. It is too restricting. If I do it's a Bogen carbon fiber, with a large ball head. However, in a dance school I always use a stand that can move with me to take some of the weight off of my body. I use a Studio Titan Side Kick. Trust me, it's too much when you are three days in to an assignment with two more to go! I have a 12-foot trailer that is my best friend for dance schools, and I could not work without it.

I work on an Apple Mac. I love the PRO Select software for my sales presentations and use it for a number of things in post-production to help expedite the process. Another piece of software that I could not live without is my Ron Nichols retouching pallet. It's a serious time saver and I can't imagine retouching anything without it.

THE DANCER

Whether you are a seasoned professional or just starting in photography, this book will teach you how to direct and work with dancers. It will give you practical advice on your workspace and the equipment needed to get the most out of every dance session.

The posing examples provided will spark your creativity and passion for photographing dancers and give you ideas for working with dance schools and more advanced dancers. From dance schools to working with professionals, this book addresses many of the questions you need answered to get you excited about working in the field of dance photography.

In a dancer, there is a reverence for such forgotten things as the miracle of the small beautiful bones and their delicate strength.
— Martha Graham

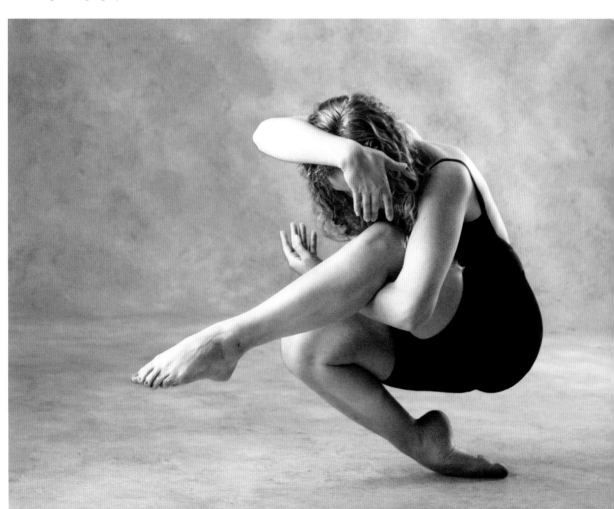

Dancing Is All About the Feet

Declan came to the studio for a portrait session. When she saw this tutu—from Enchanted Fairyware, she would not stop until I let her put it on. Her mom came to me because I had photographed her sister at one of my dance schools. She said, "Show Miss Susan how you can point your toe." And there you have it, a two-year old with great feet. Not all dancers are born with great feet. They are God given. Dance is all about the feet.

Dancers start young. They genuinely work really hard, and just maybe they grow up to be a ballerina!

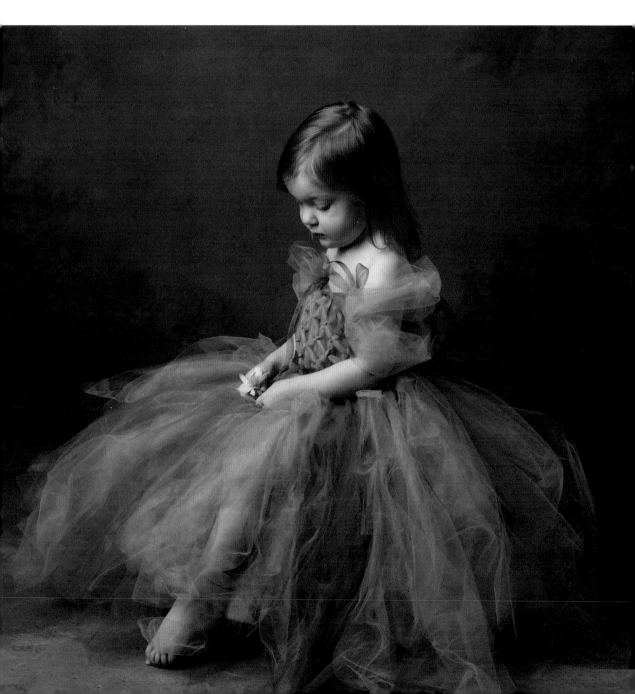

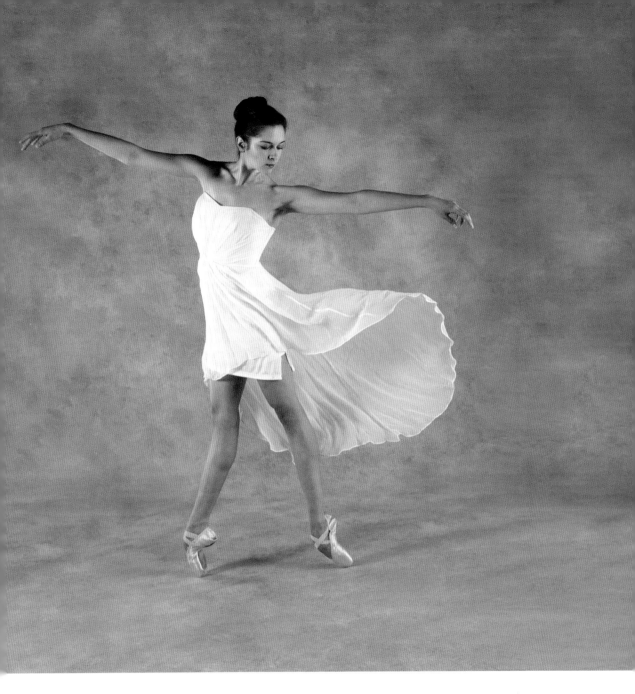

Dance Chooses You

There are not many subjects more interesting to photograph than dancers. There are few artists more dedicated to their craft than dancers. Learning to capture the essence of a dancer is a gift that can be both rewarding and fulfilling. The work ethic of a dancer is unparalleled. The love for the art of dance starts at a very young age and continues long past the dancers prime. It has been said, "You do not choose dance—dance chooses you."

THE BASICS

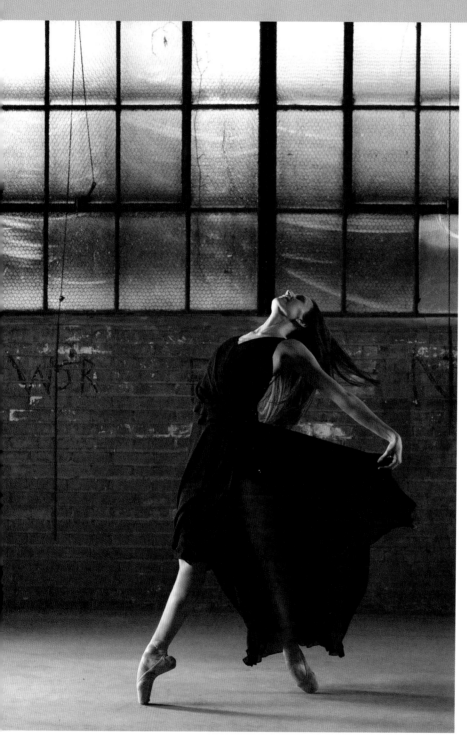

Understand How to Communicate

Dancers are beautiful and willing to indulge your artistic vision. Photographers love to photograph dancers. It would be hard to find a more graceful, elegant subject. Whether you photograph dancers occasionally or on a regular basis, understanding how to communicate with them will help you elevate your images to new levels.

Many Business Opportunities

There are many business opportunities as a professional dance

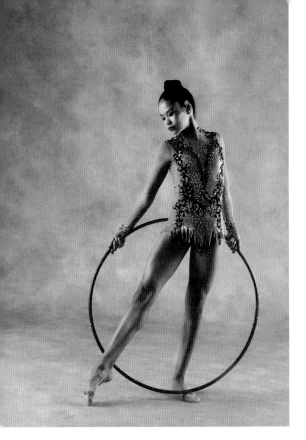

Gymnastics

Photographing rhythmic gymnastics and gymnasts are a natural progression if you love to photograph movement. Both are challenging, but will be similar to working with dancers in many ways.

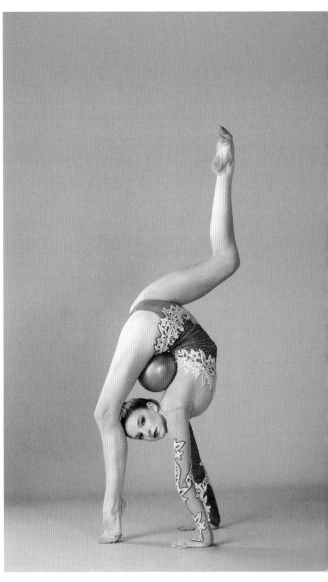

photographer. While photographing a dance school is very different than photographing a private session with a professional dancer, many of the techniques and communication skills needed are similar. The following are just a few of the opportunities in professional dance photography:

- Dance schools

- Private sessions with amateur or elite dancers

- Senior sessions

- Rhythmic gymnastics

- Professional dance sessions

- Ballroom studios

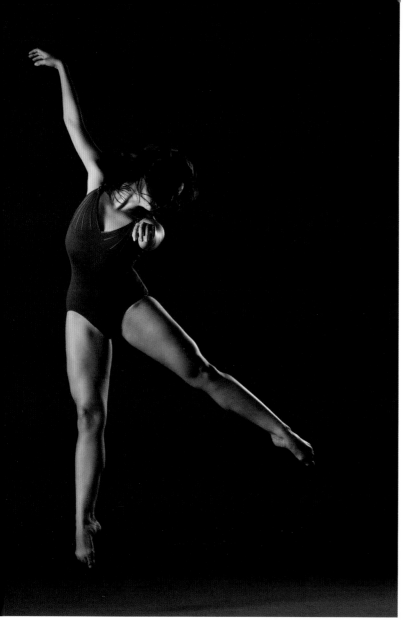

Be Prepared and Confident

It is important that you are prepared and confident in your ability, if you want to get the very best out of your subject.

Technical Knowledge and Artistic Vision

There is as much technical knowledge involved in working with dancers as there is artistic vision. Knowing your camera and its capabilities and limitations are a big part of dance photography.

A Camera Made for Capturing Sports

In many situations you will be pushing your camera to its limit. Camera choice can make a big difference in your ability to capture dance images. Some cameras do not have the response that others do. Just a second of lag can make it very difficult to properly capture a jump or leap, especially in a live situation. Choosing a camera that is made for capturing sports and has a faster reaction will enable you to follow motion.

Learn as Much as You Can

There are many situations for you as a photographer to photograph a dancer. If you are interested in photographing dancers, you will want to learn as much as you can about working with dancers. Your knowledge of their craft will give you the tools needed to create amazing images.

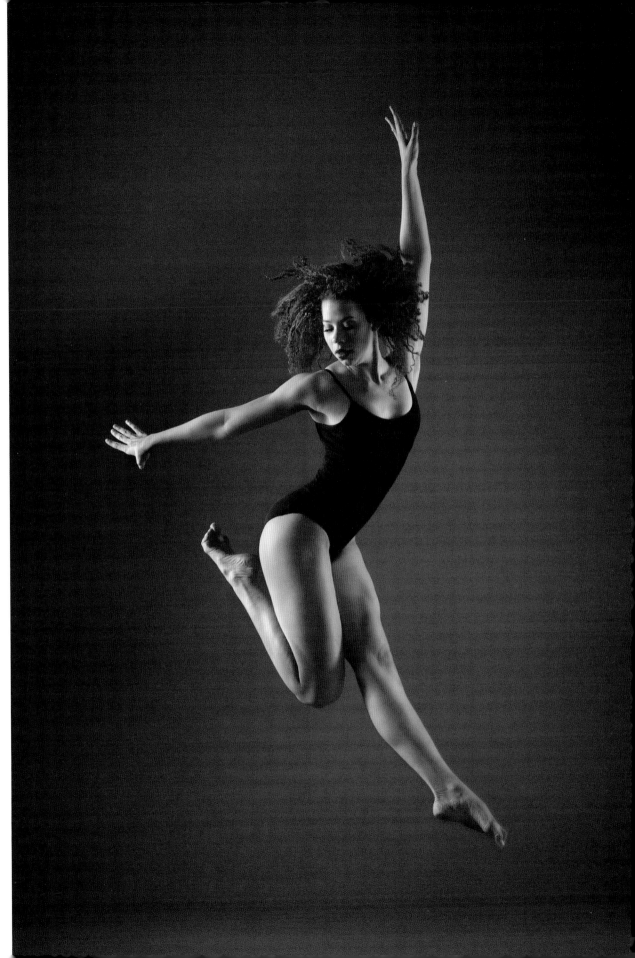

WORKING TOGETHER

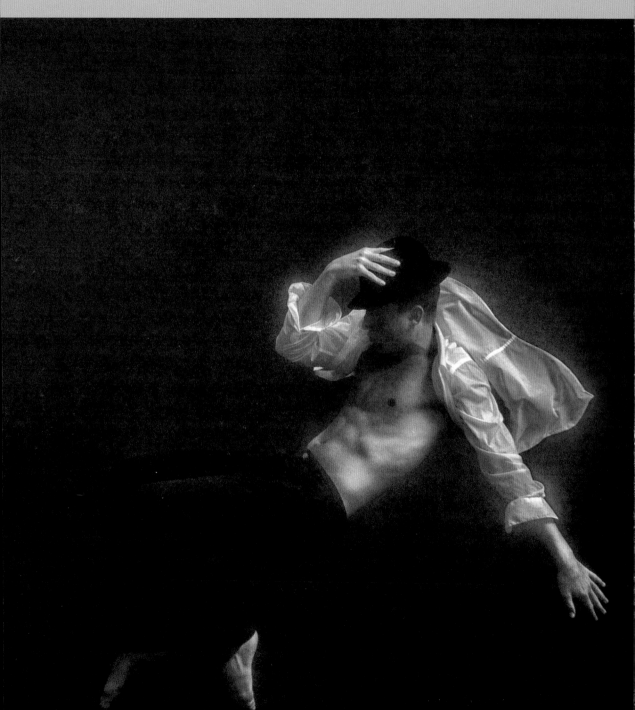

Dancer and Photographer: Artists at Work

Passion and skill are needed with any specialty that you choose as a photographer. Choosing to photograph dancers, who are artists themselves, is challenging and visually exciting. Dancers are performers and enjoy photography sessions. They enjoy the artistic process. A session with a dancer is unlike other sessions, you now have two artists at work, and both have a vested interest in the success of the images.

Prepare, Preplan, and Be Ready to Instruct

Unlike models, who are expected to get on set and know what to do, dancers are use to being directed. They perform other people's choreography and are instructed throughout their career. I have rarely been in a session where an instructor or other dancers were not present. Dancers are use to this, it is how they work. This can be a great help to the photographer, especially if you are not as experienced with photographing dancers. Most dance sessions are fairly involved and require a good amount of pre-planning. Not having the right equipment or a good idea of what you want to do in your session can make the session difficult.

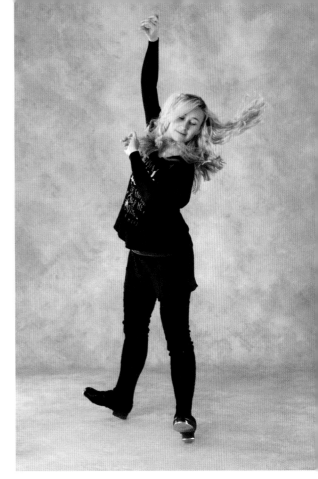

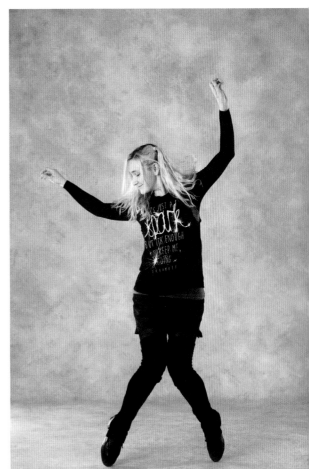

Be Aware of How Long a Dancer Can Give 100 Percent

Dancers, while dedicated, do not have an unlimited attention span. They do not like to wait around while you figure things out. In the best situation, a dancer should arrive on set once everything is tested and ready to go. Being organized and respectful of their time will go a long way with them. During a session, you can usually tell when you have hit your time limit with a subject. While this can time vary, once that happens, the session needs to end. Since dancing is so physical, you need to be aware of how long a dancer can give you 100 percent.

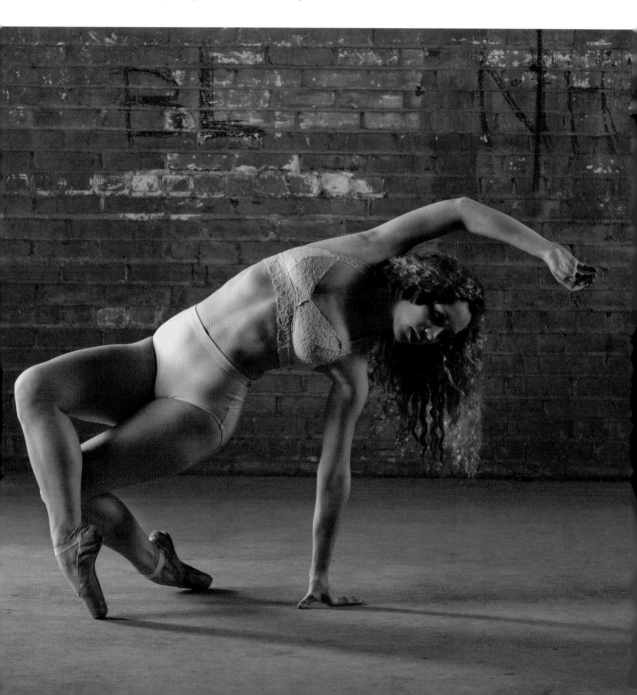

The Dancer's Need to End the Session

Many photographers who do not photograph a dancer often will push too hard and try to get too much out of a session. Sometimes professional dancers simply become bored after a while and want to be finished. While this is usually not the case, when it happens, you can feel it and will need to finish the session. Every dancer is different and their ability to perform for you can vary greatly. As a professional, it is important that you understand this and proceed accordingly. Respect them and they will respect you.

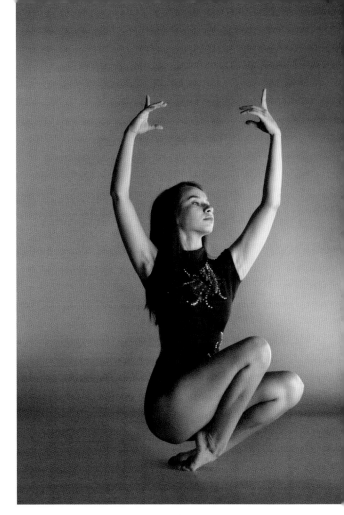

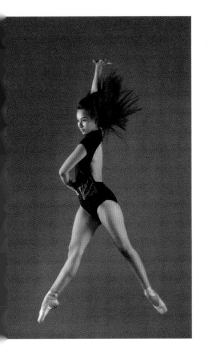

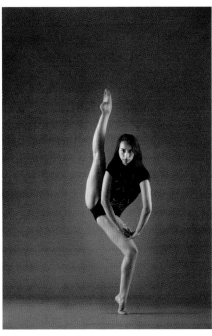

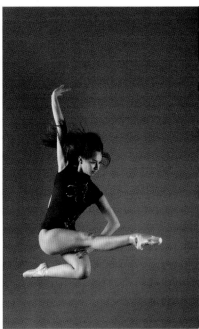

You must be aware . . . and not have unrealistic expectations of what dancers you photograph may be able to do.

A Dancer's Strengths and Weaknesses

Every dancer has their strengths and weaknesses. Not all are amazing at leaps, not all were born with great feet. Some are not very flexible. Ask them, and a dancer will be happy to tell you what their strengths are. Photographing a dancer doing something they feel they are good at will always result in better images.

Have Realistic Expectations

Unless you live in New York, or a large city, chances are there are not many professional dancers in your area. Many of the images seen on the internet or Pinterest are of professional dancers. You must be aware of this and not have unrealistic expectations of what dancers you photograph may be able to do.

Many dancers dance because they love it and don't necessarily have the skill set required to do some of the things

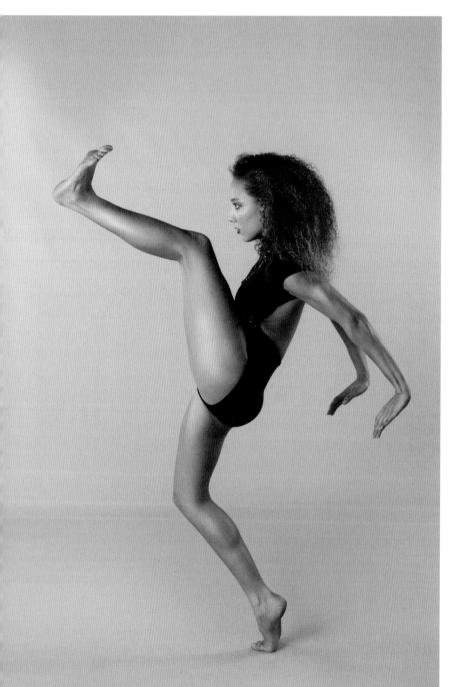

you see on the internet. Also, keep in mind that Professional dancers' bodies are very different than that of even a very advanced teenage dancer. As their body mature the muscle tone changes dramatically.

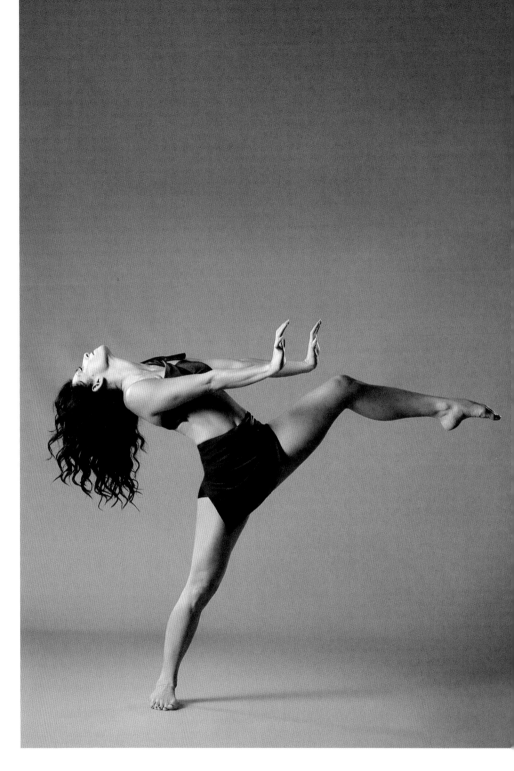

Professional dancers bodies are very different than that of even a very advanced teenage dancer.

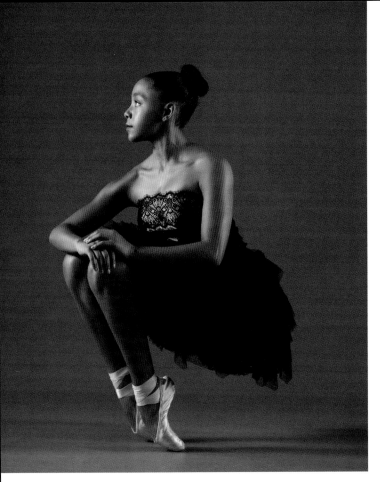

Speak to Dancers, Learn their Vocabulary

Learning to speak to dancers is the key to success for dance images. Many photographers will shy away from directing a dancer because they lack the vocabulary to properly communicate. There is no way around the fact that it can take years of struggling through mispronounced terms and frustrating moments to feel as though you are able to communicate what you want to see. The best way to begin learning how to speak to a dancer is to listen to them. They are happy to share and love to hear you try to pronounce *grands ronds de jambes.* There is nothing like hearing a photographer from the south trying to speak French.

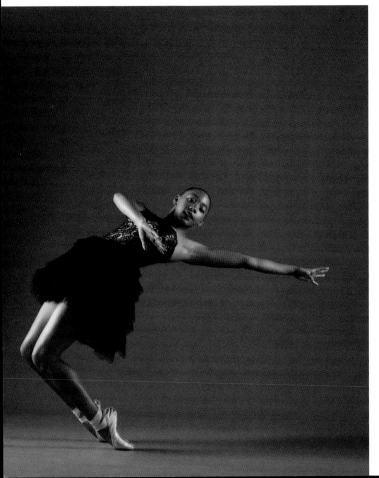

Control the Session by Communicating

An inexperienced photographer will think that a dancer can get in front of a camera and somehow magically know what to do. Often the photographer is happy to let someone else control the session because they don't have the needed skill set to properly communicate. Dancers prefer to be directed, in fact they are used to it. It is not uncommon to have a dancer stand in front of you and ask, "What

do you want me to do?" Dancers are not models. It is important to understand the difference. While some certainly will have ideas, many will not. Ultimately, controlling your session and getting the best out of a dancer will depend on your ability to communicate with them.

Dancers prefer to be directed, in fact they are used to it.

Expectations

Dancers speak in specific terms when referring to a position or pose. Find a more experienced dancer or, even better, an instructor and offer to do a test session. Let them know that you are trying to better communicate with dancers and ask that they speak about positions and correct you if you mispronounce something. If you hear a term you are not familiar with ask them about it. They will be happy to help you out. In the beginning it will feel overwhelming, but after a little practice you will be surprised how comfortable you will begin to feel in your sessions.

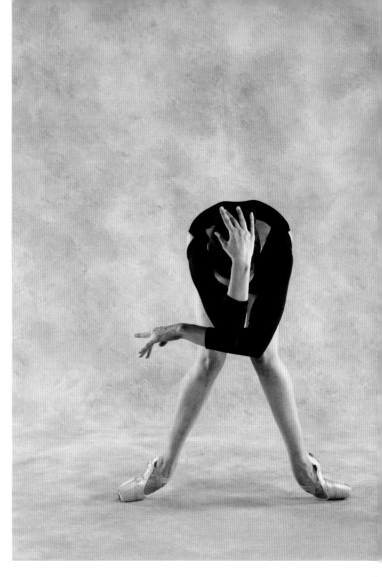

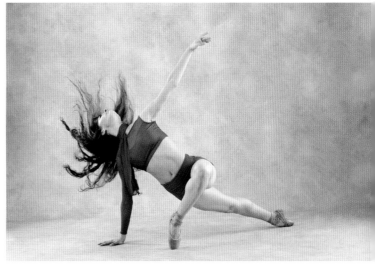

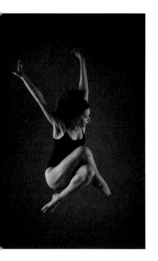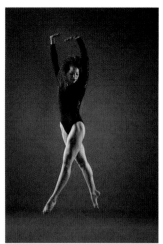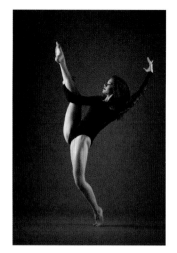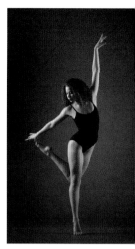

There are two different sets of terminology that will help you better communicate with a dancer . . .

Start an Image Folder

Start collecting images on Pinterest and save them in a specific folder. As you become more aware, start saving them in multiple folders according to the type of dance it is. For example, pointe, contemporary, partners—whatever type of image you are interested in. This makes it much easier to locate during a session. It's perfectly acceptable to show a dancer an image and ask them if they can recreate the pose. But don't get into the habit of relying on images. Ask a dancer what that position is and continue to work on your ability to communicate with them.

Two Sets of Terminology: Dance Positions, and Theatrical Terms

There are two different sets of terminology that will help you better communicate with a dancer: dance positions and theatrical terms. The two are very different, and once you understand how to properly direct a dancer your images will improve. While positions or shapes communicate to the body position, theatrical terminology refers more to the positioning on the stage within the scene, or where in the background you want them to stand specifically. This will also help you better communicate how you want them to position themselves for the lighting. When using very forgiving lighting, such as with a very large softbox, this may not be as important. However, when using very dramatic lighting where the position needs to be very specific this will be critical.

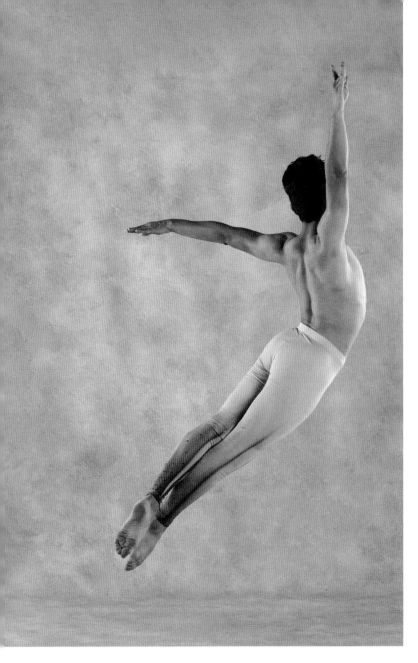

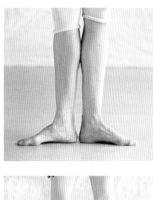

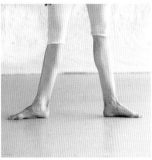

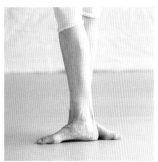

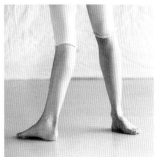

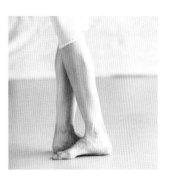

Know Basic Positions

The images on the right show from top to bottom: first, second, third, forth, and fifth basic ballet positions for feet. Knowing key terms and these dance basics can make directing the dancer much easier and working together more successful.

Terms Help to Communicate Simply

Communicating with a dancer does not need to be difficult. Many times just telling them you want them to turn into more of a profile position is all that is needed. Using stage terms such as upstage, downstage and stage right or left, is a good start. If you are lucky enough to have a theatre background this will make sense to you. If not, don't worry! It will take some time, but you will eventually become comfortable with using terms you are not used to.

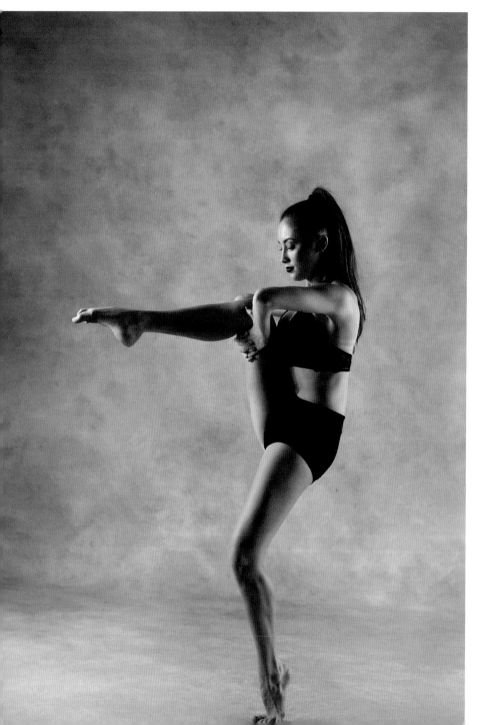

Using stage terms such as upstage, downstage and stage right or left, is a good start.

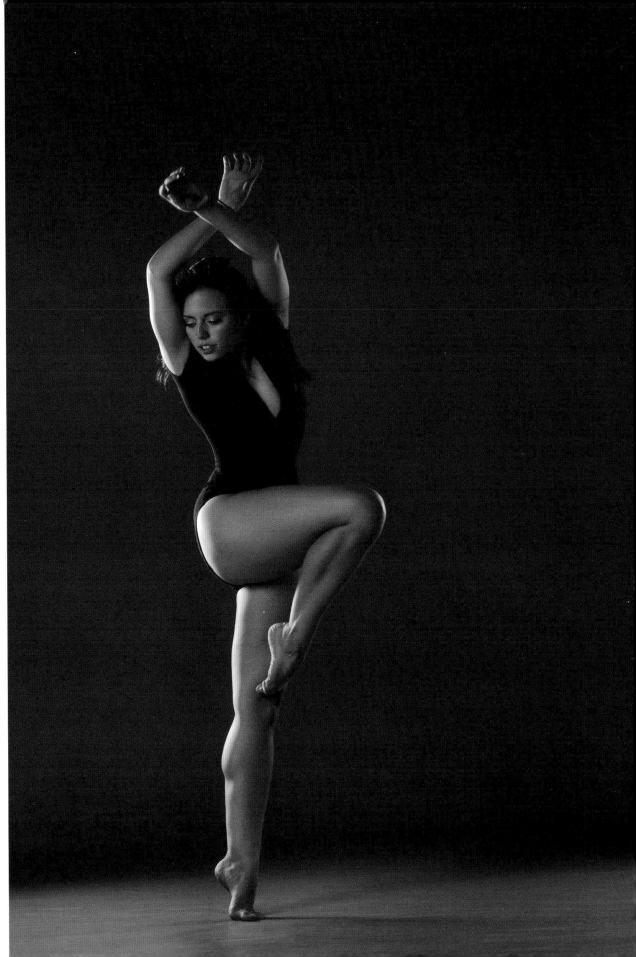

SETUP AND POSING

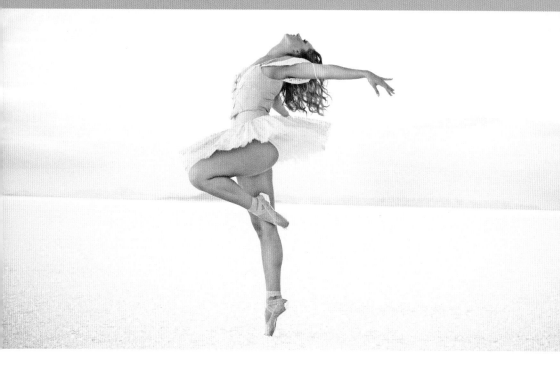

What Makes a Perfect Photograph?

Jack Mitchell was *the* dance photographer in the 1960s and 1970s. If there is an iconic shot of a dancer, he probably took it. I had the great fortune to speak to Jack when my first dance exhibit was shown in a gallery named after him. He said I have one piece of advice for you, "Never show a dancer your image and ask for their opinion—they will never be happy! There is a difference in what is perfect for a dancer and what makes a perfect photograph, and the two are not the same." Jack was a master of dance photography, and he is right, it is almost impossible to please a dancer!

Direct and Refine

The smallest change in position can enhance or kill an image. As you become more experienced, you will start seeing this. In the beginning, you will need to follow your instinct. You know what looks good. If you don't direct a dancer, there is no way you can expect them to know what you want them to do. What it feels like to them is very different than what it looks like in the camera. Become used to constantly talking to dancers during your session. Don't hesitate to refine positions or tell them something is not working, and move on.

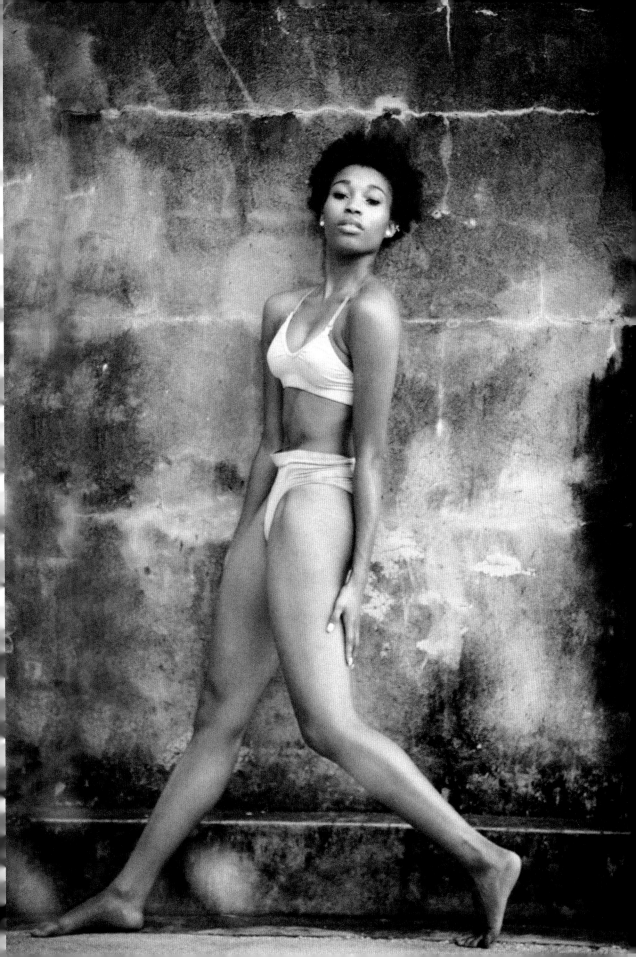

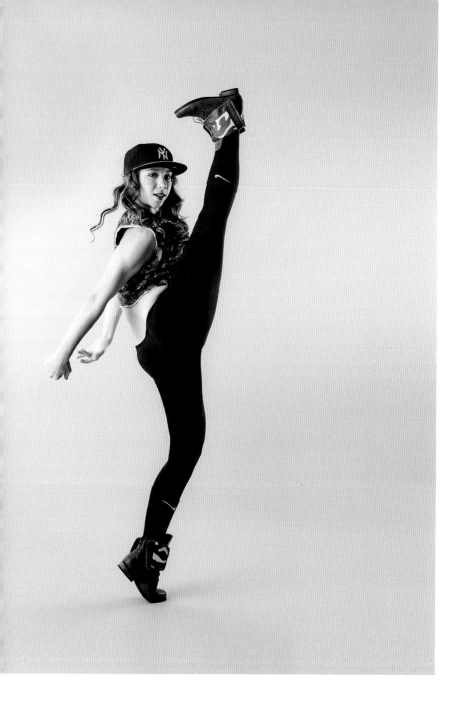

and ultimately, it will be up to you to make the call. Try not to waste time on something you know does not look good. Take a few shots and move on. Simply say, "This is not translating the way I had hoped it would. Let's change it up." Dancers do not hear that as negative. Repositioning or rethinking something is part of their everyday process.

Let Them Try, Then Move On

You will eventually be in a position where a younger dancer has seen something on Pinterest and is determined to try it even though it is way beyond their skill set. This is especially true with leaps and jumps. You can waste a lot of time trying to get something that is not going to happen.

Be gracious. Let them try. Sometimes you will get lucky, but eventually someone has to say this isn't working. If you have an instructor working with you, she will know the dancer and it may be easier coming from her.

Reposition and Rethink

Many dance positions may not translate in the camera. This is okay. A photographer knows that not all things communicate through the lens the way you think they will,

Be gracious. Let them try. Sometimes you will get lucky.

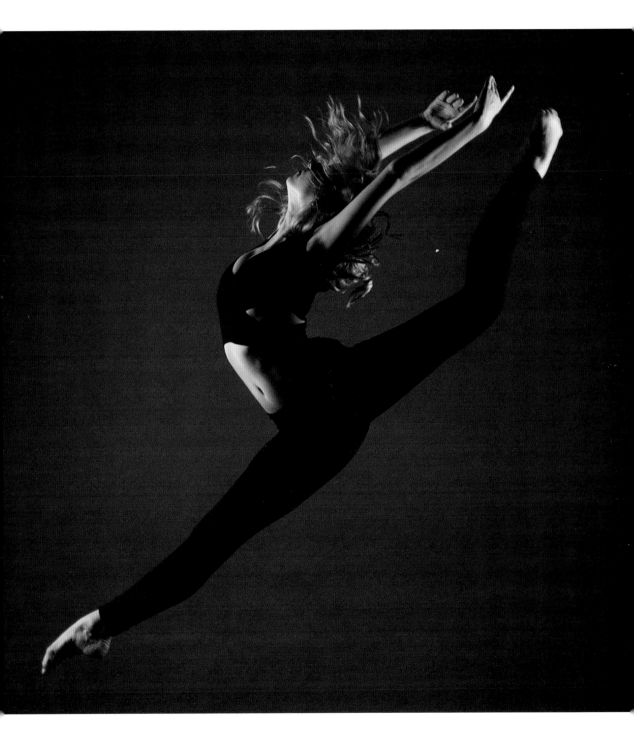

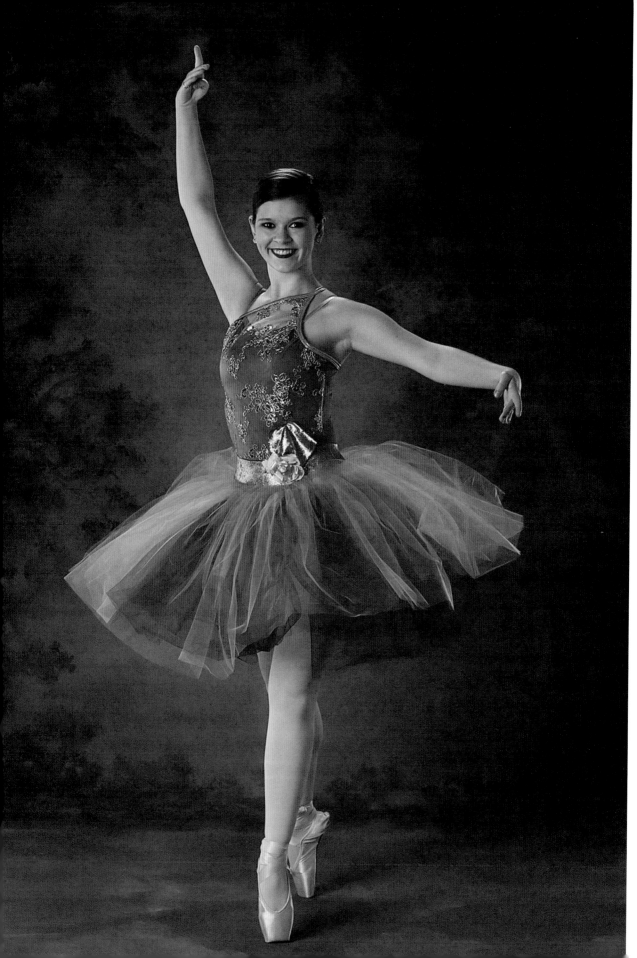

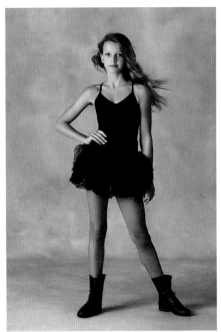
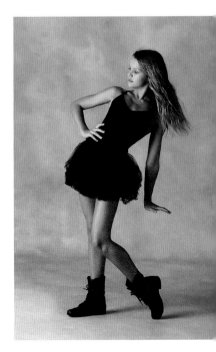

It is truly beautiful to see a young dancer with a more athletic or curvy body fully embrace their body and shine in their own unique beauty.

Avoid Unflattering Positions

Dancers are very body conscious. You need to be aware of a dancer's body in the camera. While most dancers are lean and have great bodies—this is not always the case. If a dancer has put on a little weight—even five pounds—they can feel it on their body. This will affect your session. Try to be understanding. Avoid unflattering positions. More stretched out positions can sometimes help in this situation. It is truly beautiful to see a young dancer with a more athletic or curvy body fully embrace their body and shine in their own unique beauty.

Appropriate Posing

Appropriate posing for the age is important. All the rules apply here, just as they would with any other photography session. Be very aware of what is referred to as a crotch shot. A simple refinement in positioning can make for a more appropriate and pleasing image. Dancers are very aware of this and will often call it themselves. Always try to place the body at more of an angle rather than straight into the camera. Try to be very aware of a position that is overtly sexy if you are working with anyone other than an adult. Integrity is important and both the dancer and parents will appreciate your effort.

Position the Dancer for Your Chosen Line, Angles, and Shapes

Dance is all about lines, angles, and shapes. A more experienced photographer will see this easily and should able to incorporate their understanding of this into the session. Changing an arm position to show tension and muscle tone will greatly improve a position that started out with a straight, stiff arm. Paying attention to hand position is critical. People show tension in their hands. Getting a relaxed natural hand position is key to a successful image. Using your knowledge of body positioning with a dancer is no different than with any other subject you photograph. Fluid positioning will always translate better than unnatural position.

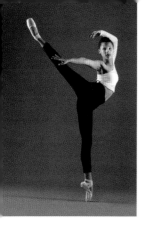 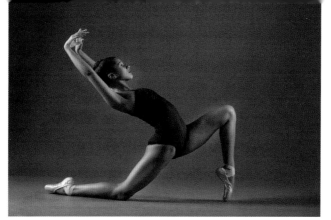 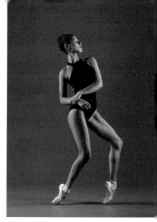

A Movement Pose Is Better than a Static Pose

An image that looks as if a dancer were dancing when the image was taken will always look better than a static image. This is hard to do. The dancer and photographer must be in sync. Try to bring movement into an image by asking a dancer to move into the pose. Counting them into it can help. If there is another dancer present, you could ask them to count for you. Many photographers make the mistake of just telling them to go and then trying to catch it when it happens. This usually does not work. It makes your subject feel like you are not sure of what you are doing. Learning how to successfully master this one thing will drastically change your images.

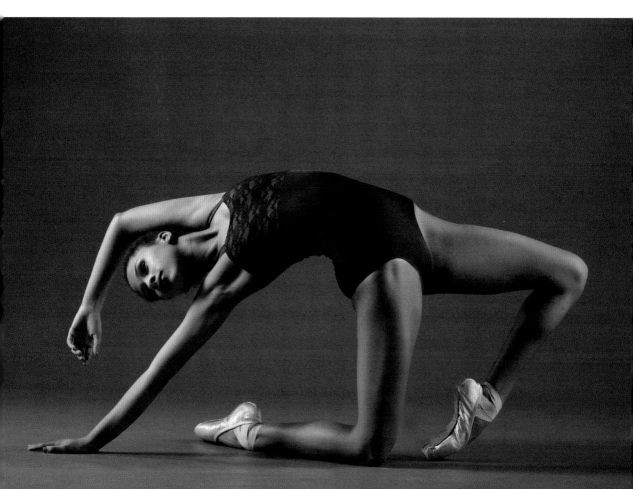

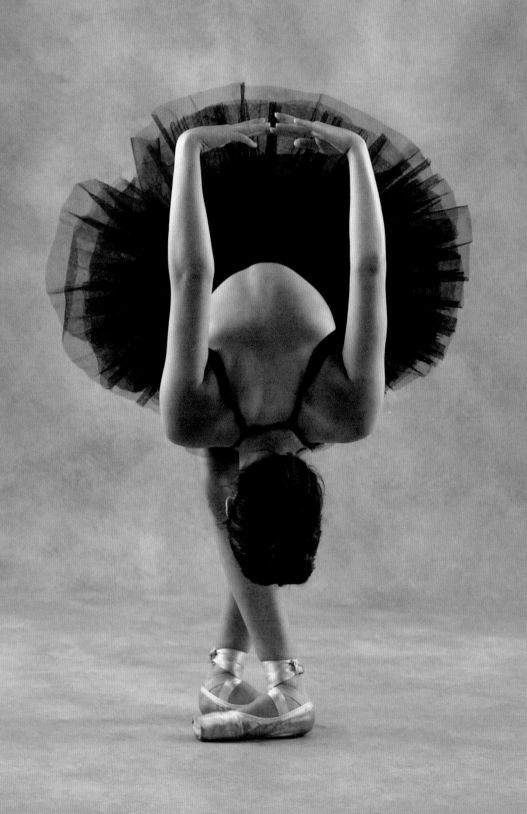

Comfortable Subjects

Dancers can be easily intimidated in front of a group of their peers. Depending on the situation, you may not have control over who is in the room. If you can recognize when this is happening, hopefully you can clear the room or speak directly to your subject as if no one else is in the room. Compliment them and tell them how great they look. Reinforce them by saying things like, "Wow—no one else has been able to do that."

We are as much psychologists as we are photographers. Getting your subject to feel comfortable in front of the camera is as much an art as actually taking the image.

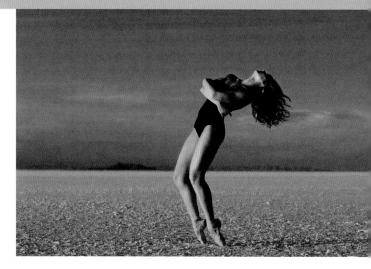

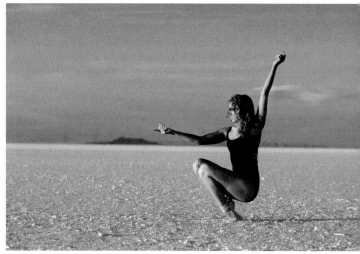

Work with Instructors

Dancers are used to being told what to do. Even professional dancers depend on directors and instructors to correct them. This is a part of the dance world that never goes away. In many cases, you will have an instructor working with you, especially if you are in a dance school. How you work with an instructor is critical to your success. You cannot depend on them entirely, yet letting them have input will be very helpful. This is really no different than working with a parent in the room when you photograph a child. Respecting each other is important. Make every effort needed to get instructors on your side and help them understand your vision.

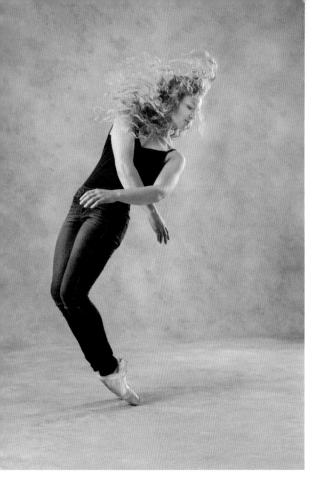

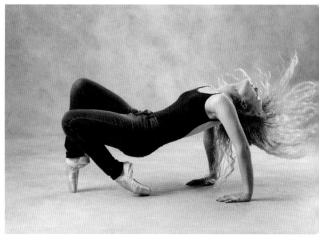

Advantages to Working with the Experienced

Hiring a more experienced dancer to work with you on a session is a great way to learn dance terms. They can help you choose poses and speak to your subject. They can also watch for technique issues the dancer might not be aware of. It is critical that you begin to understand the feet, and what they should look like. Pay close attention to how dancers speak to each other and you will soon start to see and understand exactly what they are talking about. It's always fun to have an instructor tell me, "Wow, you saw that when I didn't." You are then on the way to becoming a great dance photographer!

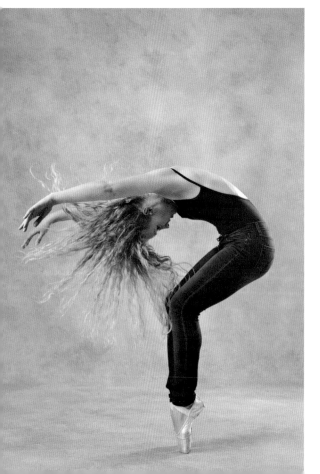

Start with the Feet

There is nothing more important to a dance image than the feet. It can be a beautiful image, but if a dancer doesn't like their feet in the image, they will hate it. Not all dancers are born with the feet they wish they had. Many dancers have been overlooked by major companies simply because they were not born with the right feet. Many amazing dancers will tell you, I have terrible feet. Until you actually see what amazing feet look like, it is hard to understand how they can change an image. Once you have enough experience, you will recognize them, even in a five-year-old. If you are serious about photographing dancers, start with the feet.

There is nothing more important to a dance image than the feet.

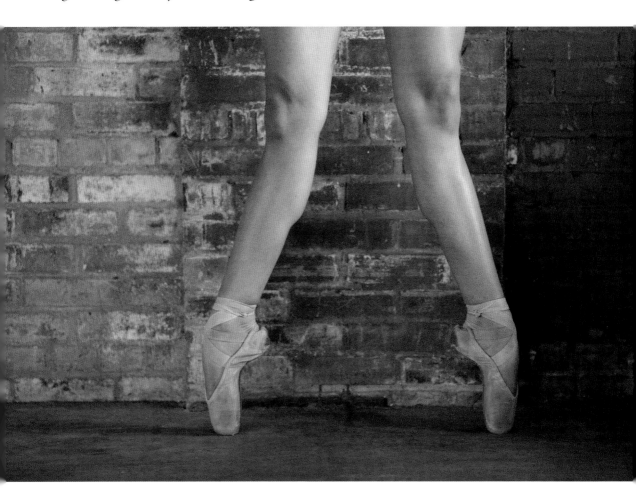

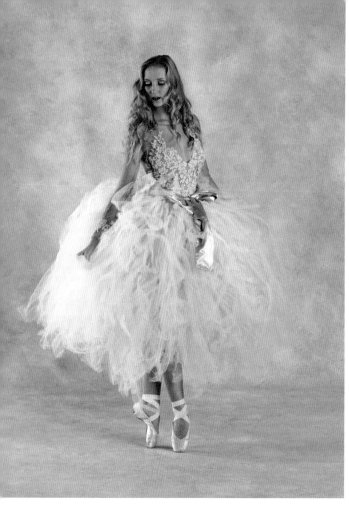

Things will normally be rushed and will not give you much time to be creative.

Plan and Organize for Schools

Photographing dancers in a dance school is very different from a private dance session. Things will normally be rushed and you may not have much time to be creative. Depending on the school, you may have to photograph as many as 400 dancers in multiple costumes. Photographing dance schools, while fun, is a *lot of work*. There are so many things that need to be in place to be successful. Organization is important. While you always want your images to be the best that they can be, in this situation, the importance of artistic expression is far down on the list. Having a plan and working your plan is critical.

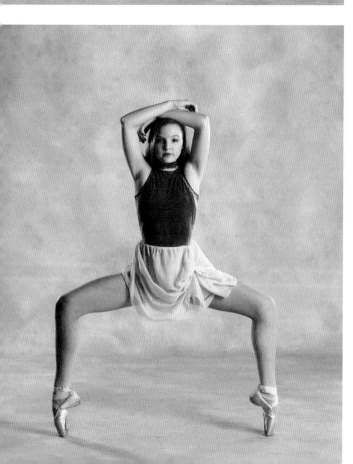

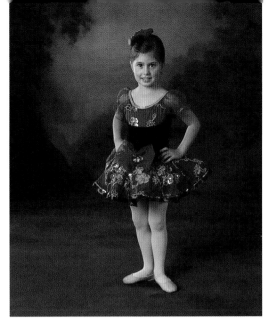
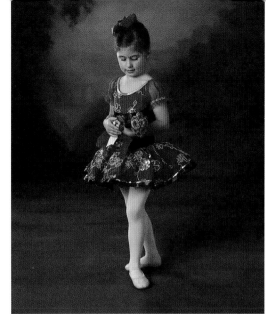
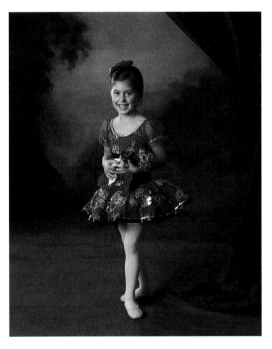
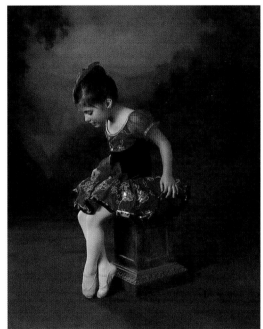

Give Parents Image Choices

If you don't photograph it, they cannot buy it. Many photographers take only one or two images of a dancer in a dance school. I have always tried to give my dance parents as many options as possible within the time constraints.

I use a flow posing method and have a plan, especially for the younger dancers. Parents like choices and this will help boost your sales average. Depending on the school, I may have a second set related to the theme of their recital. This is always a big hit with both the school owners and dance parents.

Use Props,
But Do the Math

I can usually accomplish ten to fifteen images of each dancer in about two minutes. If you have twenty dancers in a class you can do the math and see that you will be working non-stop the entire hour. In many cases, you will do this three hours in a row. I do the exact same poses for all the dancers in one class, and work forward and backwards through the poses. I use carefully selected props for sitting and balancing to enhance the image. These props help give a variety of poses for the parents to choose from.

Keep Your
Equipment Consistent

Dance school lighting needs to be the same on each set, if you have multiple photographers. It may take a few years to build up to having this much equipment. In the beginning, you can borrow or rent what you need. Keeping your equipment consistent allows any of your photographers to move to a different set and know exactly what to expect.

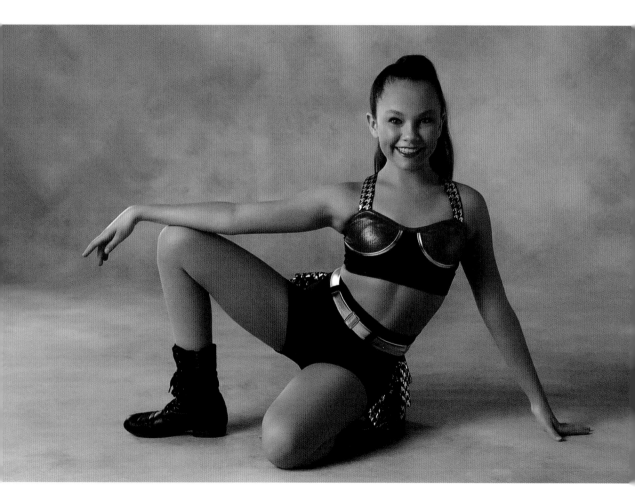

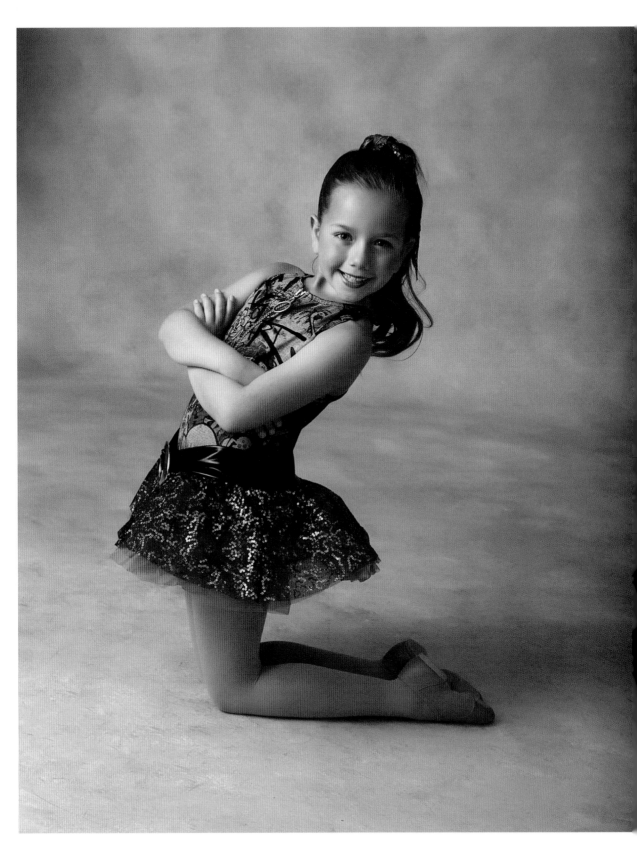

Designate a Set for Groups

There is always a set designated for groups. This needs to be a large background, usually 20x24. I always prefer canvas, but sometimes use muslin for this. The set can also be used during the day, when needed, for overflow. It is usually chosen to coordinate with the recital theme or with consideration to costume colors. The set will have two very large umbrellas providing a somewhat flat light to avoid shadows in the group pictures. If photographing an individual on this set, moving them much closer to one of the large umbrel- las gives a beautiful lighting ratio without the need to change the set up. Having a set that can serve both purposes helps logistically when things get a bit crazy on picture day.

The set will have two very large umbrellas providing a somewhat flat light to avoid shadows . . .

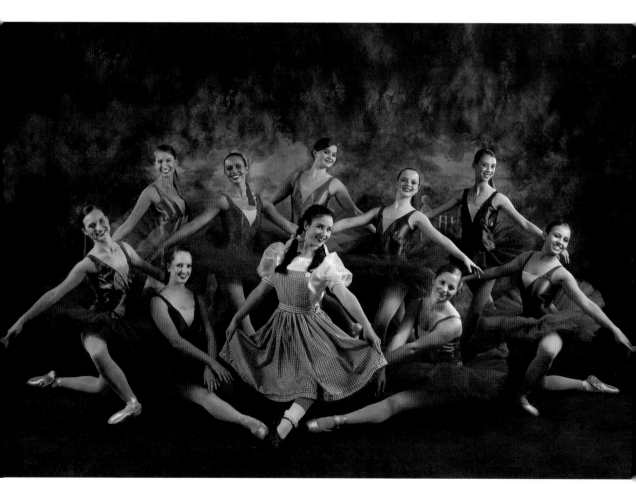

Advanced Dancers at Dance School

You have to keep things under control when photographing the more advanced dancers at a dance school. There is not enough time to do all that you wish you could do. These are not private sessions. Many of these dancers have eight to nine costumes they will be photographed in. Choose five to six poses each dancer can do quickly. I always try to include something that can be photographed as a full length and a $\frac{3}{4}$ pose, without changing the pose. You would be surprised how many of the $\frac{3}{4}$ shots parents will purchase. Choosing your poses before you start and going over them with the instructors will help you make the most of your time.

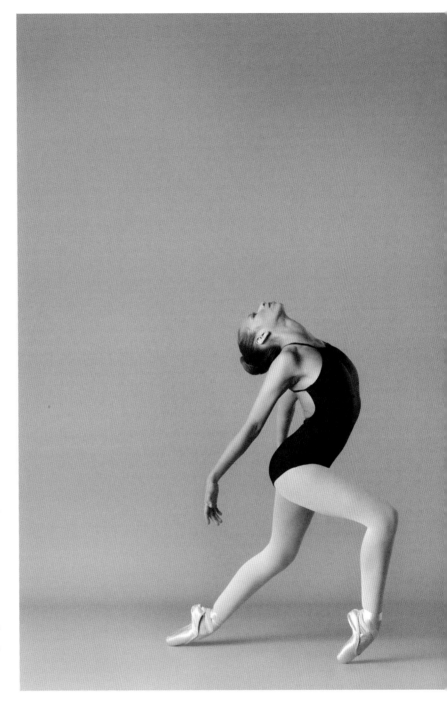

There is not enough time to do all that you wish . . .

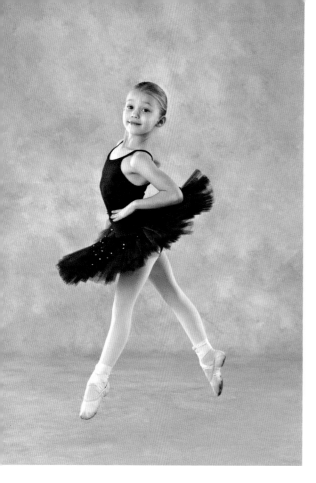

Very Young Dancers

Working with very young dancers is fun, they are so cute in their tutus. Our dance schools require that the children come in full recital hair and make up. The little dancers require slightly more time to get right. I pay a lot of attention to even our youngest dancers' feet. This requires patience. Having an extra assistant can be very helpful. Sometimes their only job is to position feet over and over again. Make sure that shoe ties have been tucked before dancers get on set, as this can slow everything down. There is usually someone in the room who can go down the line and make sure everyone's ties are tucked in and ready to go.

Having an extra assistant can be very helpful.

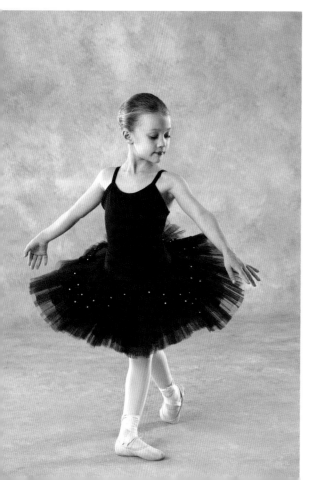

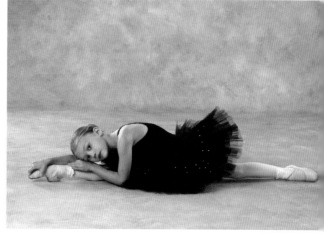

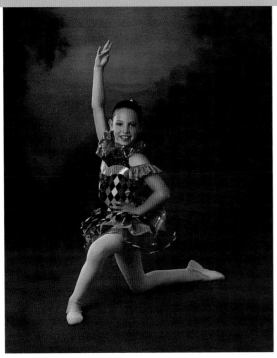

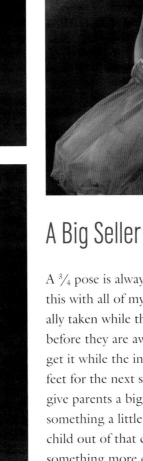

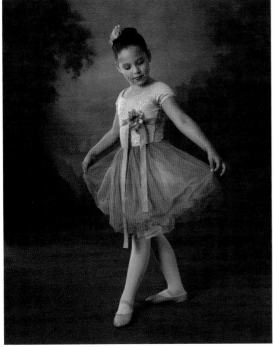

A Big Seller

A ¾ pose is always a big seller, and I get this with all of my little dancers. It is usually taken while they are seated, many times before they are aware of it. I usually try to get it while the instructors are posing the feet for the next shot. If possible, I try to give parents a big smile option, but also want something a little more classic. Getting the child out of that cheesy smile look and into something more classic and elegant works well with their beautiful costume.

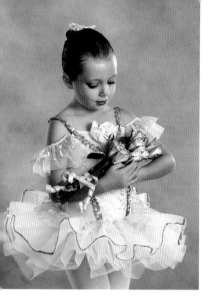 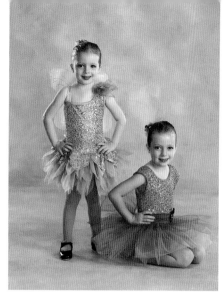 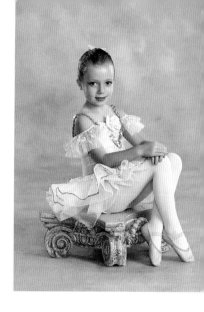

Going over poses with the instructors before the day begins will be helpful.

Instructors to Help with Younger Dancers

These dancers can be as young as three and need someone they know helping them. They know which children may have a tougher time with the poses. I have found that most instructors will work as hard as you do to help get great images. They love their dancers and want them to look beautiful in their pictures. Going over poses with the instructors before the day begins will be helpful. I have printed out 4x6-inch proofs to use like flash cards. They are not always necessary but can be very helpful when everyone is tired and in need of a little inspiration.

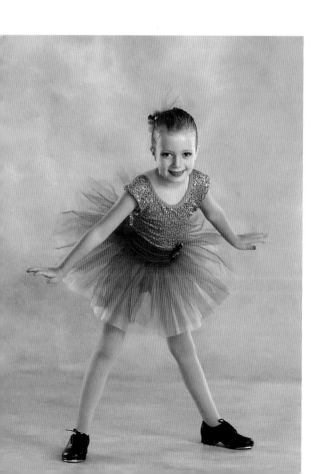

These dancers can be as young as three and need someone they know helping them.

A Non-Negotiable Rule

I never allow parents in the room during picture day. Children tend to try to please their parents and this can be a real issue. If a child is looking at a parent, they are not looking at you, and that will ruin your images. In addition, having parents instruct their child to smile never works in your favor. Dancers are used to being with their class and will usually be fine. Even if someone is having a bad day, eventually I can get a smile out of them. This is a rule that is nonnegotiable.

I would choose to not do a school if they insisted that parents be allowed in the room. It simply does not work! Dance school owners know this and will be happy to support your request.

If a child is looking at a parent, they are not looking at you and that will ruin your images.

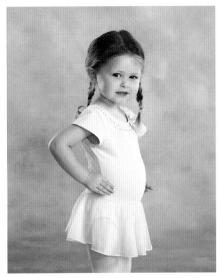
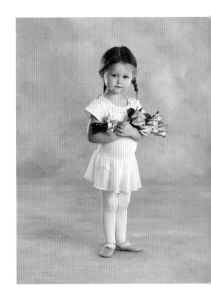

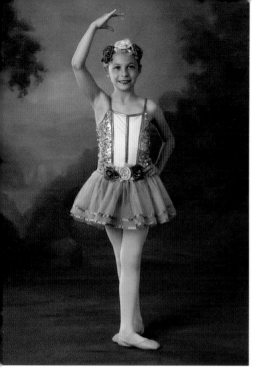

A Typical Set of Poses

Flow posing through images helps accomplish as many images as possible during a two-to three-minute time frame. This is an example of a set of images from one. Typically, I would have 3–4 images sitting, 3–4 standing, and 3–4 with an added prop such as the stage curtain. When using props it will save time to work through the set of poses and start backwards for the next child. Not having to move the last set of props saves time and keeps everything moving quickly.

This is an example of a set of images from one child.

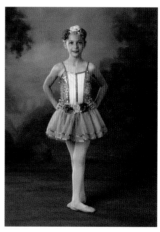

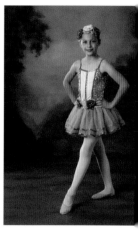

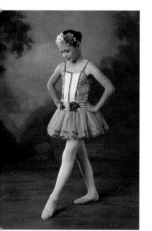

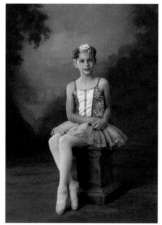

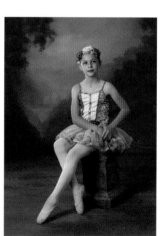

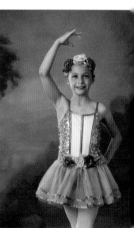

The Curtain Call

The stage curtain has been a great addition for our younger dancers. It is a very light weight velvet curtain found at a thrift store. It is hung on a rod that is held in place by a clamp on a rolling light stand. It can be rolled in and out very quickly. If you saw it in person you would never believe it would look like this in the final photograph. It has been very popular and the kids love playing with it. It adds an element of drama to the images and definitely does not look like dance school pictures.

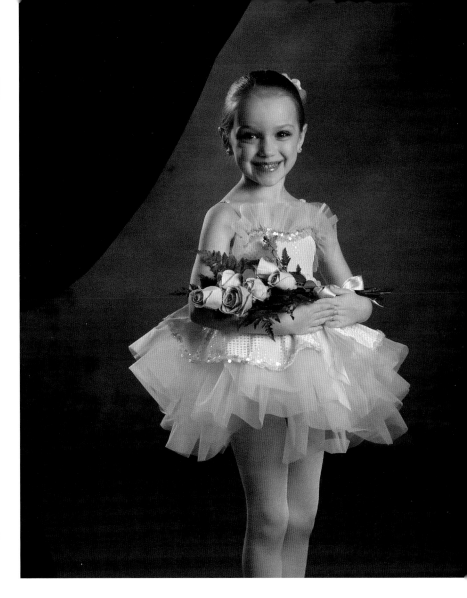

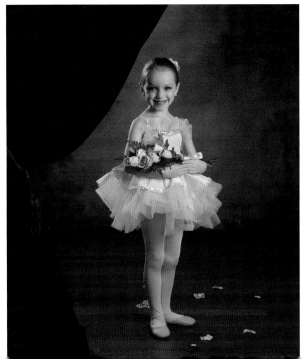

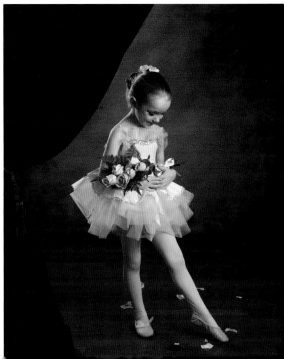

POSES FOR DIFFERENT LEVELS

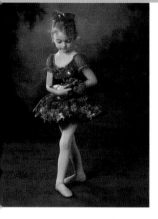 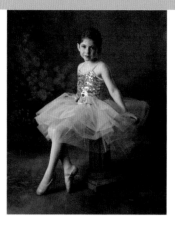 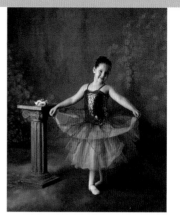 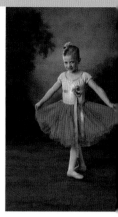

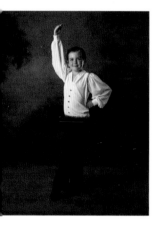 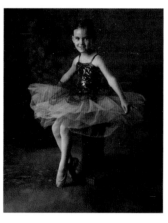 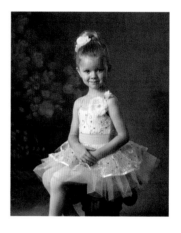 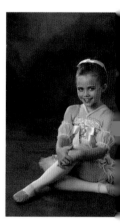

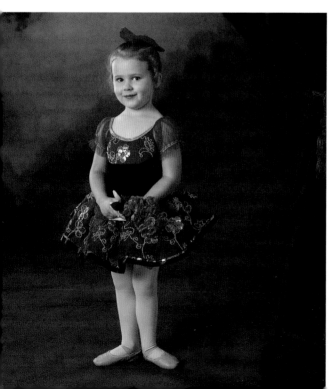

Pre K and
Kindergarten
Ballet Poses

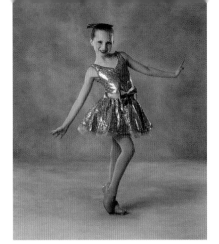
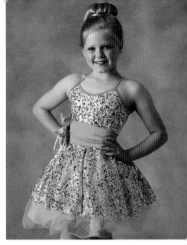
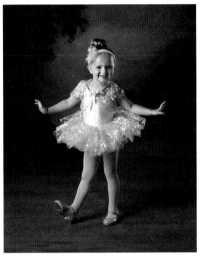
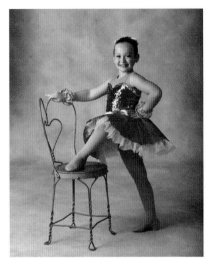
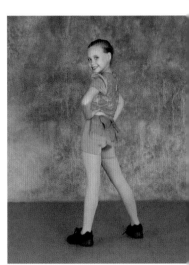
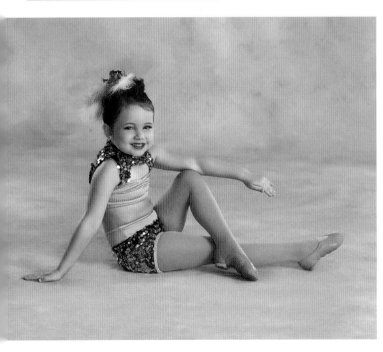

Pre K and
Kindergarten
Jazz and Tap
Poses

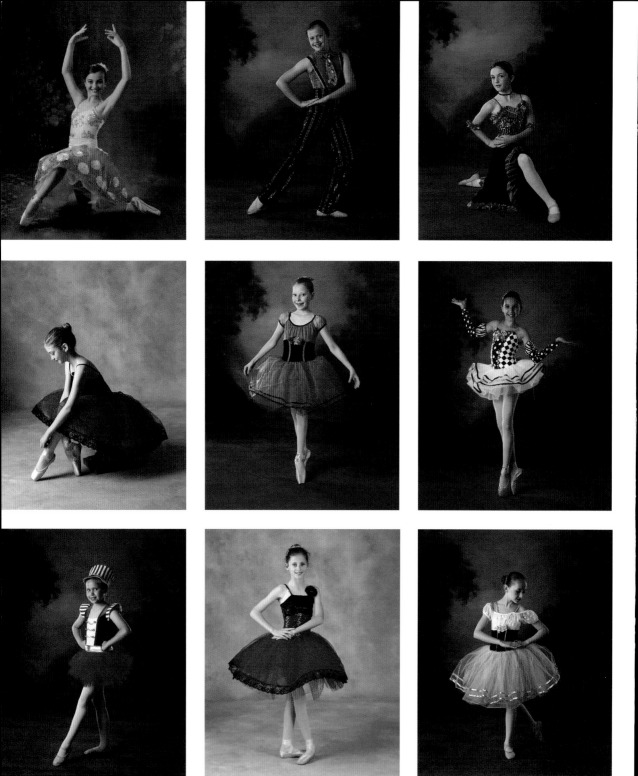

Intermediate Ballet Poses

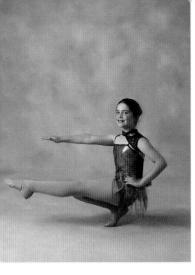

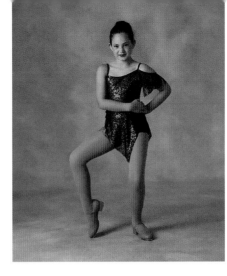

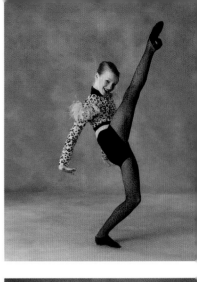

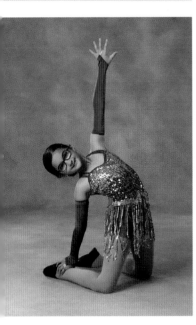

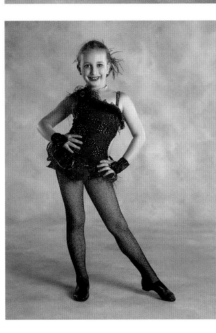

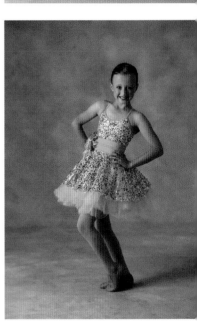

Intermediate
Jazz and Tap
Poses

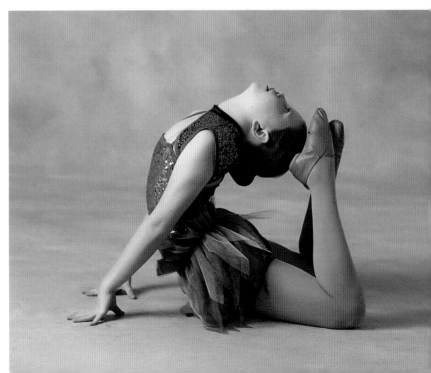

Advanced
Ballet
Poses

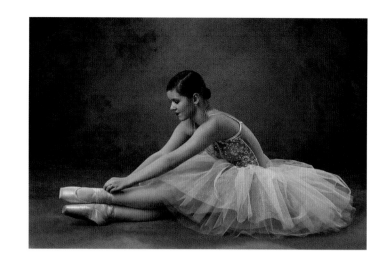

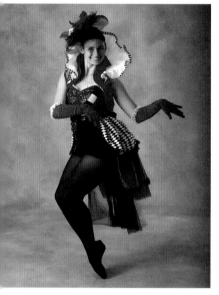

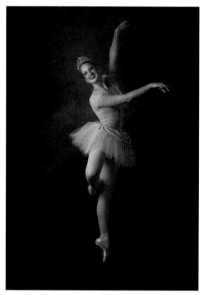

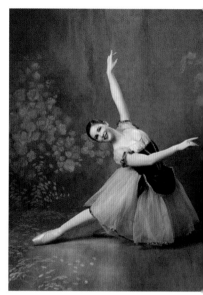

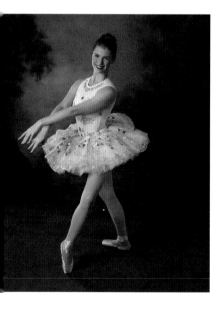

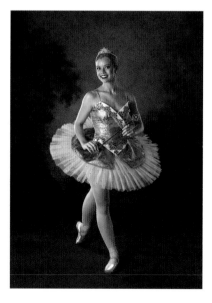

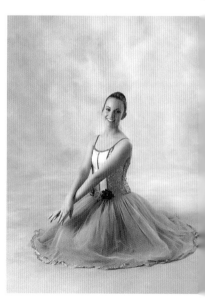

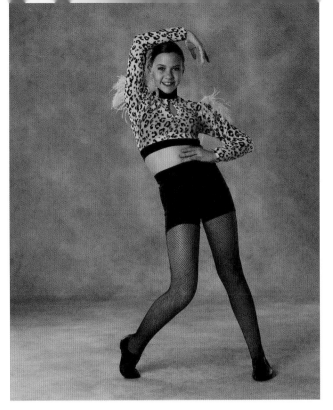

Advanced Jazz
and Tap Poses

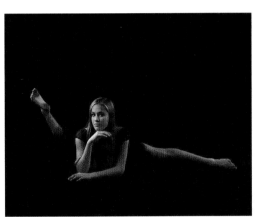
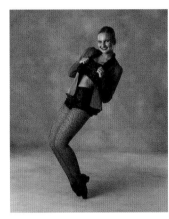
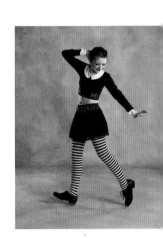

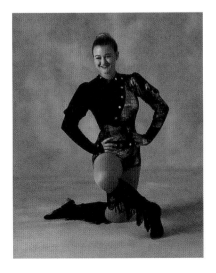
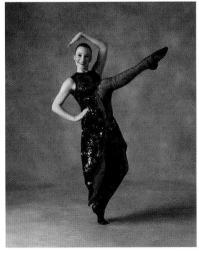
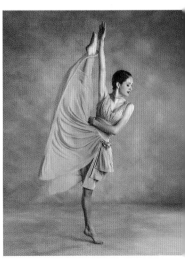

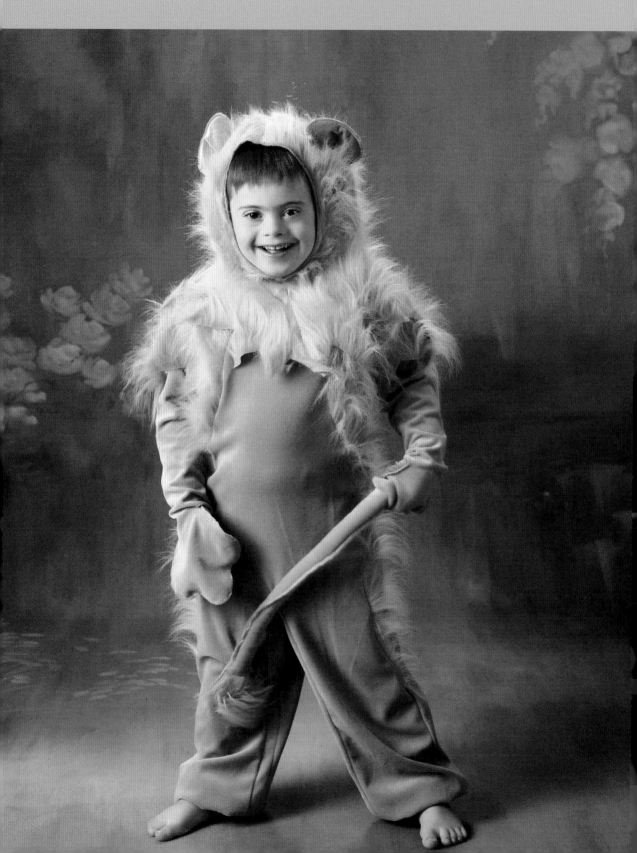

Children with Special Needs Thrive

Many dance schools have children who have special needs taking classes. Dance is great for children with special needs and many of them thrive in this environment. Ask the school director beforehand if there are any children you may need to make special arrangements for.

It is best if there is one teacher present in the room who they know and trust . . .

Recognize Their Particular Needs

A child with special needs may do better when photographed without other children in the room, as noise and movement can be distracting. Work with them and keep their needs in mind. Flashing lights can be a problem, but most are okay with this. It is best if there is one teacher present in the room who they know and trust as you work with the child. If they have a sibling who also dances, you may want to have them help, as this can reassure the child .

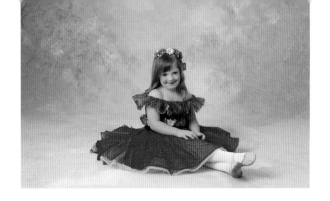

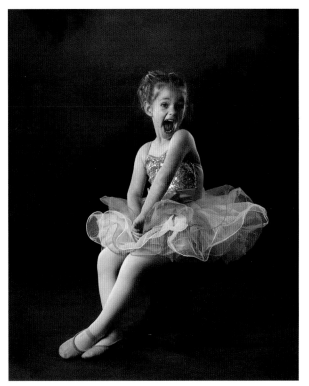

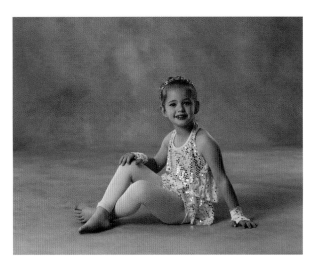

CAPTURE THE SIGNIFICANT

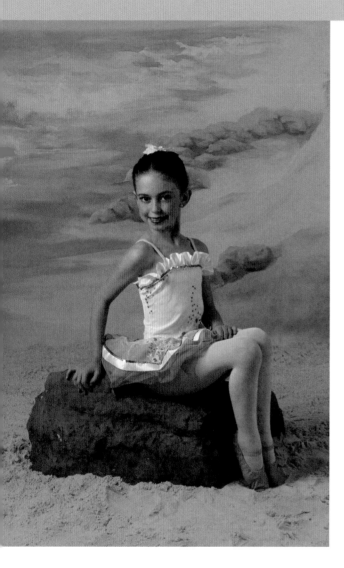

Using Sets

Over the years, I have built sets that relate to the theme of the school's recital. For the Little Mermaid, I hauled in real sand and paired it with a Denny's Manufacturing freedom cloth background, East Coast Beach. I placed a clear plastic tarp under the sand. One year, I built a fairy set for the Geppetto show. Most of these props came from Denny's. In both cases, these sets were built next to the ballet set. A child was on one set

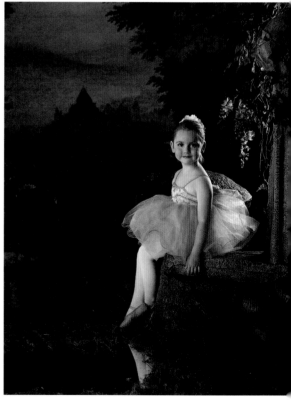

A child was on one set as we finished the last child on the other set.

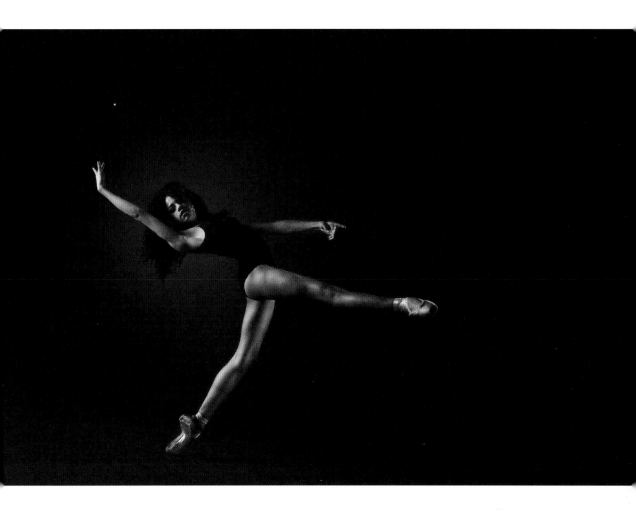

as we finished the last child on the other set. I used a rolling chair while photographing and simply moved from set to set. It is a bit of extra work, but well worth the effort. It was a big hit with the dancers and parents.

Suggest Motion with Posing Technique

Using the dancer's body to enhance motion can make for a very dynamic image. Have the dancer overly accentuate and almost fall into the pose. Catching this at just the right moment will make the image appear as if the dancer were actually dancing. These images may take a few tries before you accomplish it. The dancer needs to feel like they are falling and the photographer has to wait until the very last moment to catch the fall in the right spot for the image to look authentic.

These images may take a few tries before you accomplish it.

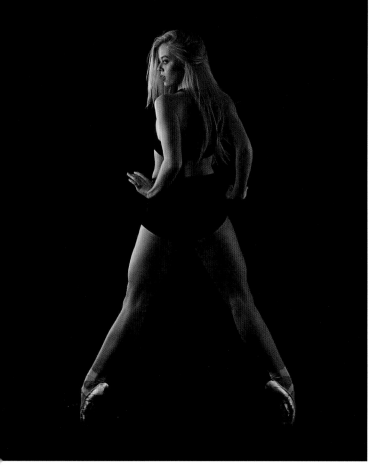

The Ultimate Goal: Dance Movement

Static poses can look very posed and uncomfortable. Your goal is to have the dancer look as natural as possible. The ultimate goal is to have the pose look as if the dancer danced into it. This gives the image motion and movement. Once someone holds a pose for more than a few seconds it can lose that natural look, so it's important that you be in sync with the dancer, almost as if you are dancing with them.

A Flowing Skirt Indicates Apparent Motion

If the dancer's costume has a flowing skirt, you can use this to help add the appearance of motion to the image. Counting the dancer into the pose as they flip the skirt of the costume will help with the appearance of motion. When trying this, paying attention to the hand position is important. Remind your dancer that their hands need to remain relaxed and appear to be moving with the skirt.

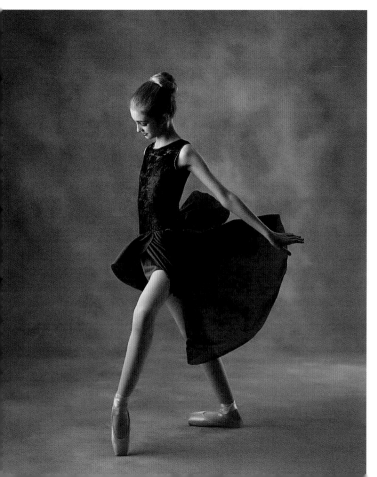

The Image Is Worth the Effort

Trust is important when trying images that are more complicated and take a few more tries to capture. Younger dancers may feel as if they are doing something wrong when all that is happening is the two of you are not in sync. Explain that it takes a little time to understand a dancer's rhythm and that the final image will be worth the effort. After a few tries, you can usually feel the dancer's timing and the resulting image will be dynamic.

Show an Example

Every dancer has their own rhythm. Dancing is very different from being photographed. It may take a little time for the dancer to relax into what you are asking them to do. If they don't completely understand what you are trying to get them to do, they can get frustrated. Dancers will work really hard to do what you are asking them to. Try to be as clear as possible. If the move is complicated, having an example to show them so they fully understand what you are asking can help.

It may take a little time for the dancer to relax into what you are asking them to do.

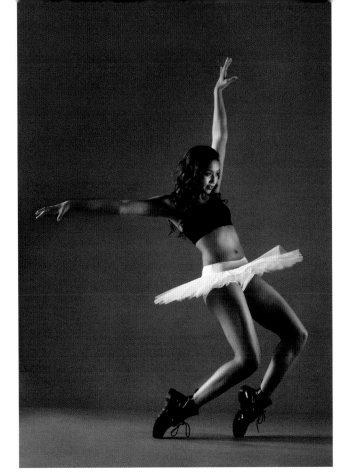

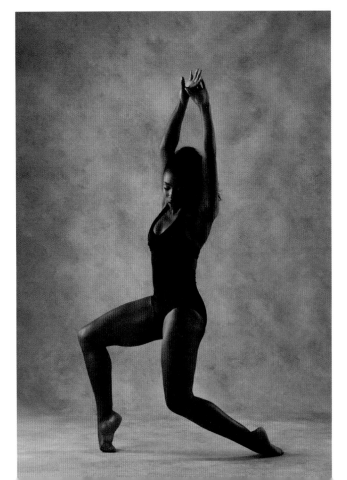

Too Many Ideas
Can Cause Confusion

3–4 ideas saved in a specific locations so they can be easily found.

Most dancers and photographers have hundreds of images saved on their phone or iPad. While this can be a great reference during a session, if your images aren't organized, this can be problematic. Searching for an image interrupts the flow and momentum of the session. Starting a session with too many ideas can cause confusion. It is better to have

Searching for an image interrupts the flow and momentum of the session.

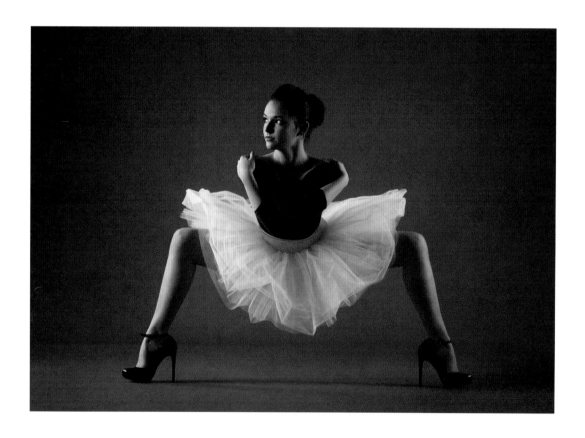

Too Much Input Can Confuse

It is not uncommon during a session to get sidetracked by too many ideas. Perhaps, when looking through images, you notice something new and all of a sudden you're trying that position rather than the one you started with. Or maybe there are other dancers in the room who start coming up with their own ideas. Everyone is trying to help and they do not see that their input is actually slowing things down. Now, the subject is confused—and it is up to you to respectfully take back your control of the session

Be On the Same Page as Instructors

You will benefit from having instructors work with you, as long as you are on the same page. Dance teachers have danced for many years themselves and will bring many ideas to the table. Paying attention to them and how they communicate with the dancer is a great way to learn some of the dance terminology.

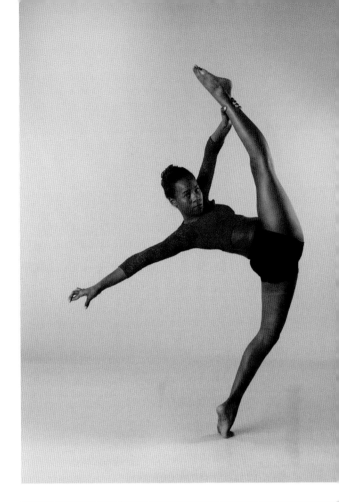

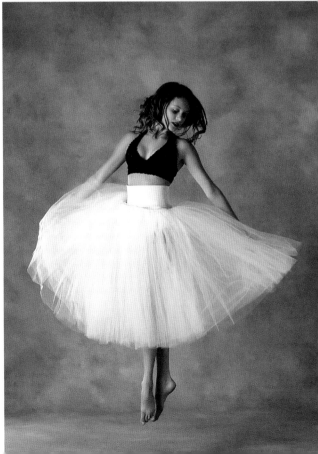

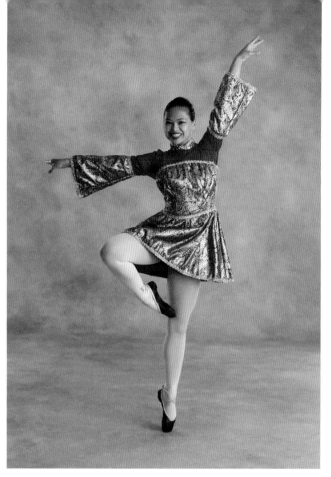

A Neutral Background Frames the Subject

There is no time to change backgrounds during a dance school session. It is important to choose a neutral background that works well with any costume. Red, pink, and teal are big on the list of colors you may need to work with. You will want to get the most out of any background you use. This background from David Maheu has been the perfect choice. Not only does it work well with any color, it looks great in black and white.

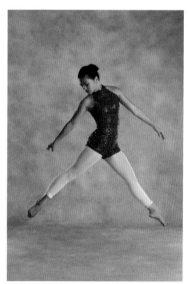

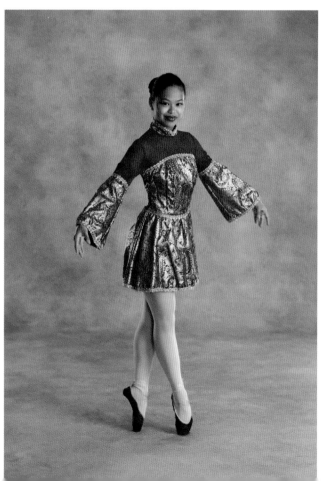

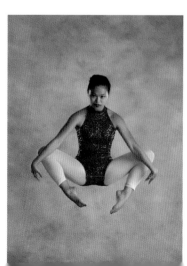

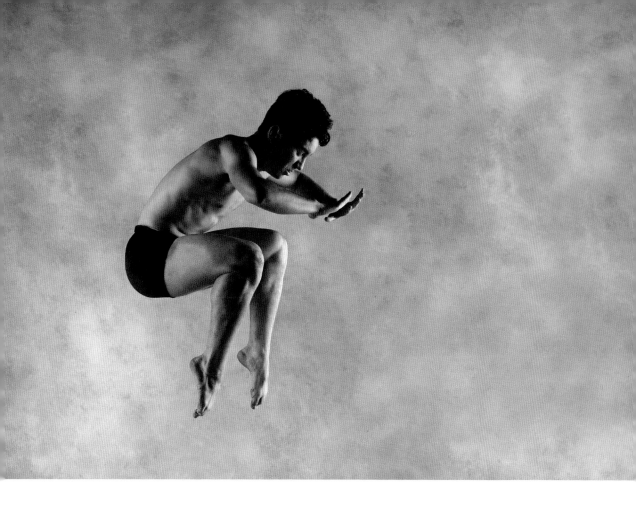

Just Let the Magic Happen

Being ready for the unexpected during your session can result in spectacular images. Sometimes things don't go according to plan and all of a sudden you see something inspiring, and you go in a completely different direction. This is okay, and can result in fantastic images. Every now and then, you need to let things fall apart, get loose, and just let the magic happen.

Sometimes things don't go according to plan and all of a sudden you see something inspiring, and you go in a completely different direction.

Find the Dancer's Rhythm

Finding a dancer's rhythm will help give your images authenticity. Experience will help with this. All dancers move and feel differently. Watching how a dancer falls into a move can give you clues and help you sync with a dancer's movement. While this may sound odd in the beginning, once you have experience photographing dancers, you will understand it completely. Pay attention and be aware and eventually this will become second nature to you.

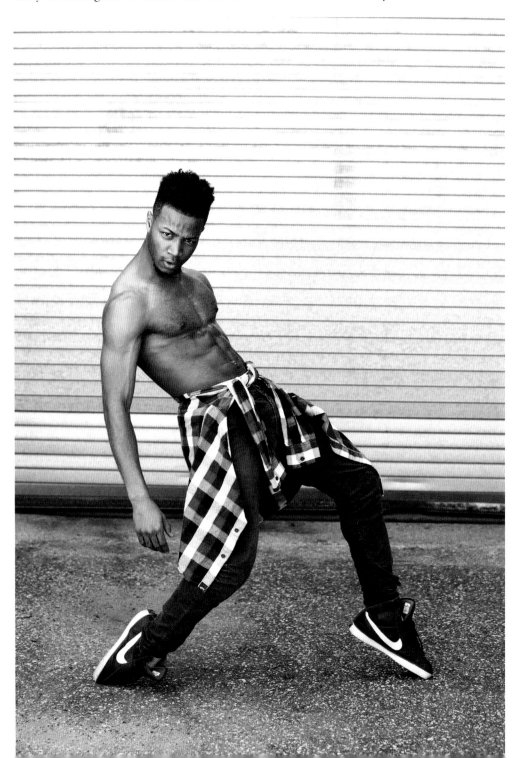

Dynamic and Challenging

There is nothing more fun to capture in dance than leaps. They are dynamic and challenging. Understanding that all dancers have their own way of approaching leaps will help you get better results. Some dancers prefer to count in their head while others really need to hear it counted out loud. The biggest mistake a photographer can make when photographing leaps is offering no count and expecting to catch the leap as the dancer randomly moves into it. The best way to learn how to do this is have another dancer or instructor count for you. Use this opportunity to learn, eventually you must be the one counting them in.

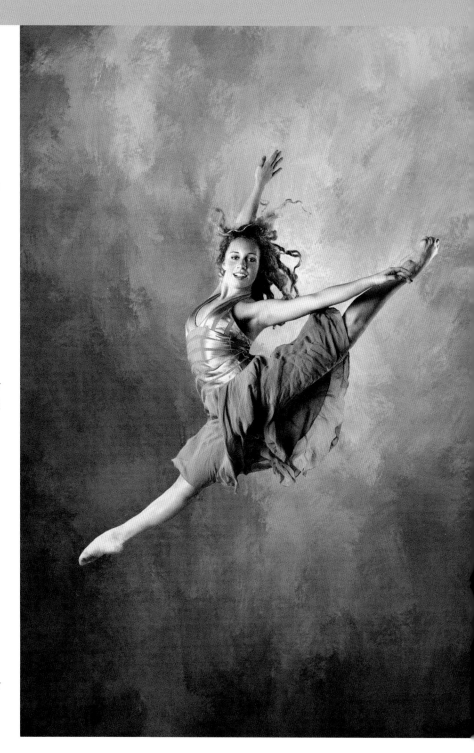

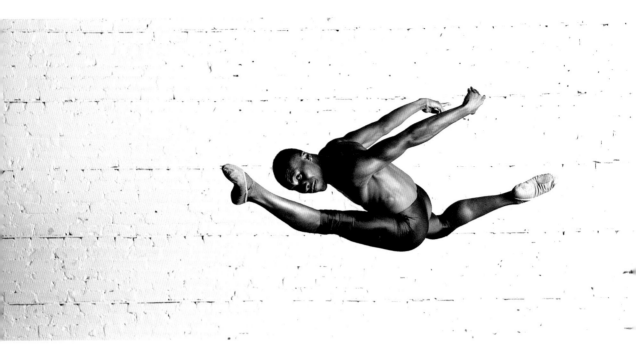

Timing is Everything – Count

Timing is everything, and only experience will help you become completely confident with capturing leaps. If you have danced or have a musical background, this will be very helpful. A dancer can either run into a leap or jump into it starting by standing in place. Depending on the leap and the dancer, one or the other can work better. If you are having a hard time with a dancer running into a leap ask if they can try it from a standing position. You will need to count it off, but sometimes this can take care of the issue.

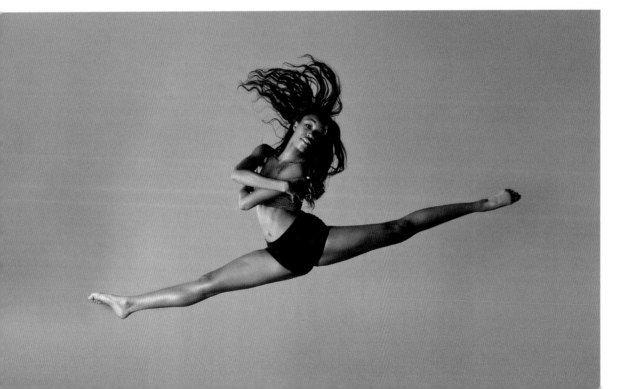

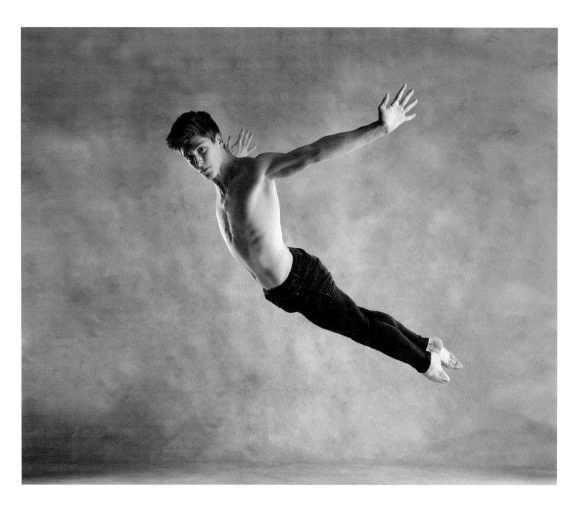

Capture Leaps in the First Few Attempts

A dancer can only do a leap so many times before they become tired. Once this happens, your opportunity to capture the leap is gone. Leaps are physical and require a lot of energy. The best images will always be captured in the first few attempts. Depending on the dancer, you may only have 2–3 attempts before the performance starts to suffer. Asking a dancer to continue after this is a waste of time. They simply do not have the stamina to continue trying. Be respectful of this and move on.

Recognize Ability

Occasionally you will have a dancer who can leap repeatedly many times and not be winded. This is an opportunity to capture great images. These dancers are usually more advanced and have many different leaps they can perform. Really watch the feet and make sure they are pointed. A flat foot can ruin an otherwise amazing image. Don't be afraid to push a dancer you know has the stamina needed for these type of images. Recognizing the dancer's ability can result in amazing images.

Pay Attention to the Details

While many leaps are rather common, occasionally you will photograph more advanced dancers who can do some unique and complex leaps. Accomplishing these images are very rewarding for both the photographer and the dancer. These leaps may require a number of attempts. Pay close attention to the details. Make sure the feet are pointed and the hands are in a relaxed and interesting position. Nothing is more disappointing than to accomplish a complex image only to decide later that other important details were missed.

They Will Try the Leaps

All dancers, especially younger ones, want to try leaps. For whatever reason, sometimes it just will not work. You cannot photograph something that does not happen. Sometimes the dancer simply cannot perform the leap they are trying. It is okay to say this is not working. Even if they are disappointed the dancer will usually understand. In the case of this image, a great jump was no problem!

Time for a Classic Portrait

These sisters danced in the same company and wanted a few images together. Always try to include one of them dancing, as well as a classic portrait. Even in dance clothes, this is a beautiful image Mom will want to have.

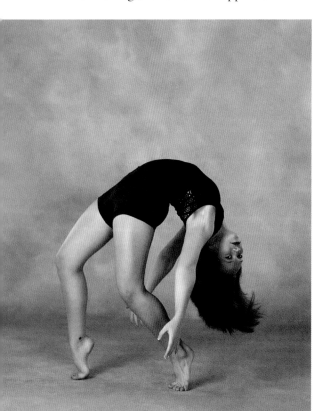

These leaps may require a number of attempts. Pay close attention to the details.

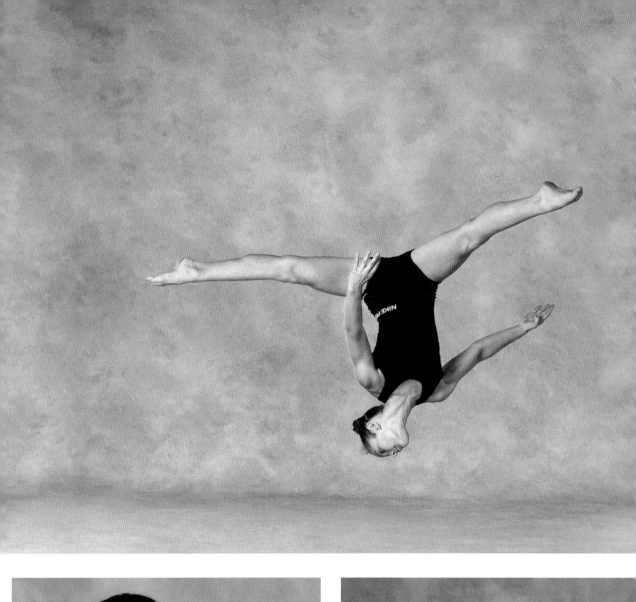

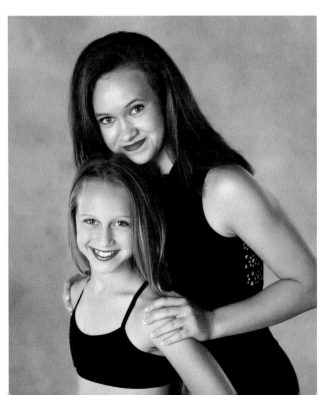

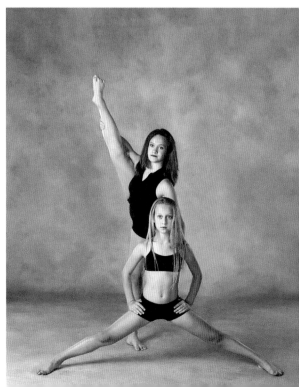

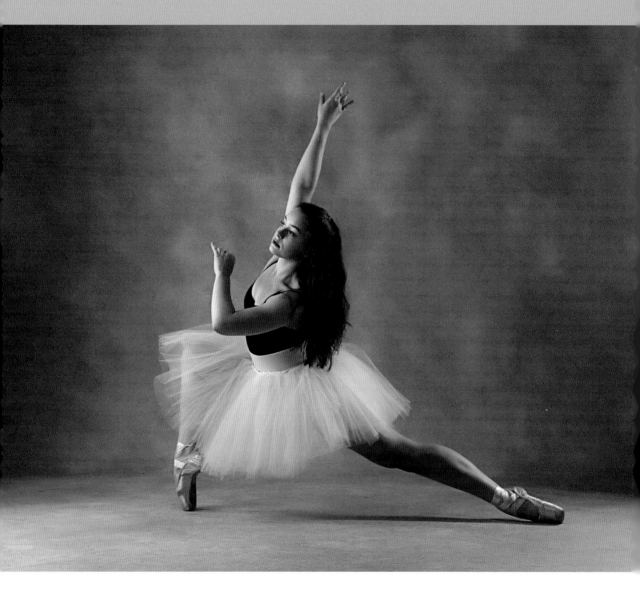

Size of Work Space

The most important aspect to a workspace when working with dancers is the amount of space you have to work in. Most dance schools have large rooms. This makes things much easier. Some schools have small spaces and you will be working a little harder to get what you want. Ideally, you will have at least a 15-foot ceiling and a room that is 30x30 or larger.

A Good Space for Photographing

I have a private studio but my space is not big enough to comfortably photograph a dancer older than eight. The ceilings are too low and there is just not enough room to move. I am fortunate to have dance friends, that have large spaces I can borrow to photograph in. Working in someone else's space requires you to seriously think abut what equipment you need to bring in for a session.

Canvas Backdrops

I prefer canvas backdrops when photographing dancers. While heavy and harder to move, they provide the most stable situation for the dancer. They don't slip and slide like muslins can. There are many options out there for flooring and backdrops, and while I have used some of them, I always go back to a canvas background. I prefer a 12-foot wide canvas. This is the right size to give an older dancer room to move and leap.

Safe Floors for Dancers

Injury is common in the dance world. Most dance schools have marley or spring floors installed to protect the dancers. You can lay your background on top of these floors making it safe for the dancers during your session.

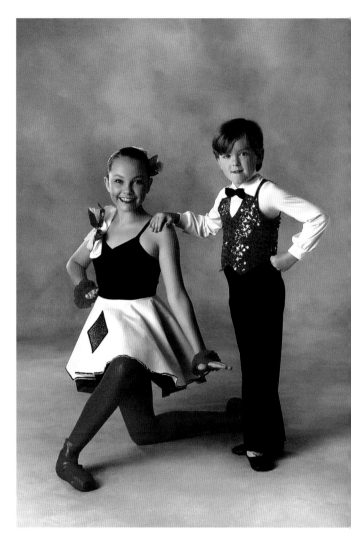

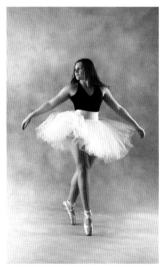

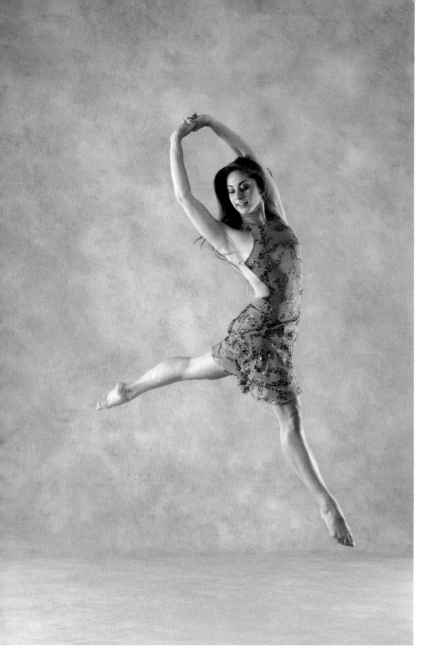

Keep Floors Clean

There is *nothing* more important to your post-production work with dancers than making sure you keep your floors clean. In a dance school, this is critical. Nobody needs to waste hours cleaning messes off of floors in post production. Over time, your floors can take a beating as dance shoes can be brutal on them. I try to make sure we sweep all of the floors as much as possible to get rid of stray feathers and sequins. It is easy to get lazy. Cleaning marks from pointe and tap shoes often will keep your post-production work to a minimum.

There is nothing more important to your post-production work with dancers than making sure you keep your floors clean.

Safety Should Come First

Keep your workspace clean and clear of cords to avoid mishaps. Tape down any loose cords and add weight to light stands if needed. The dancer's safety should always be your first consideration.

LIGHTING

Lighting Makes or Breaks the Image

While there are many technical issues involved when photographing a dancer, few will be as important as lighting. Lighting can make or break an image. There are many options for lighting and it can be confusing when trying to make the best choices. Since dancers will often be moving while being photographed, stopping the motion will usually be a requirement. Understanding what you want your final image to look like will determine the equipment needed.

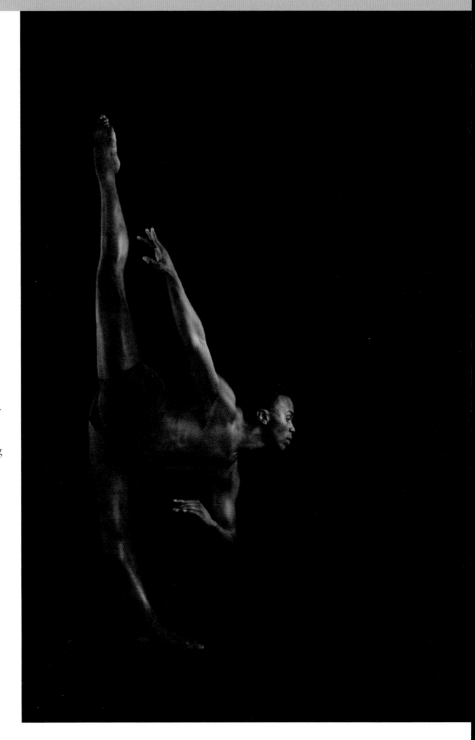

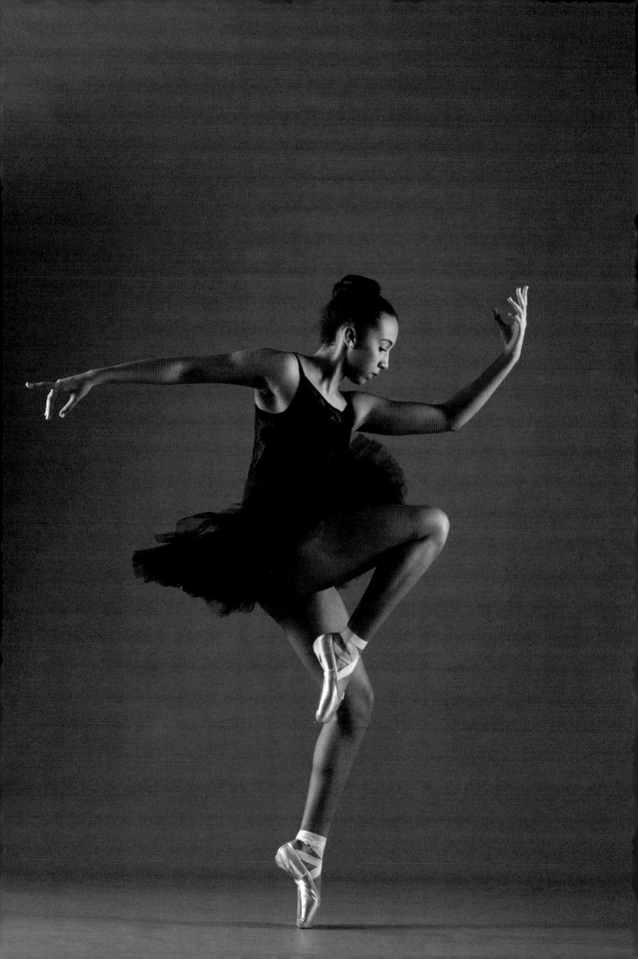

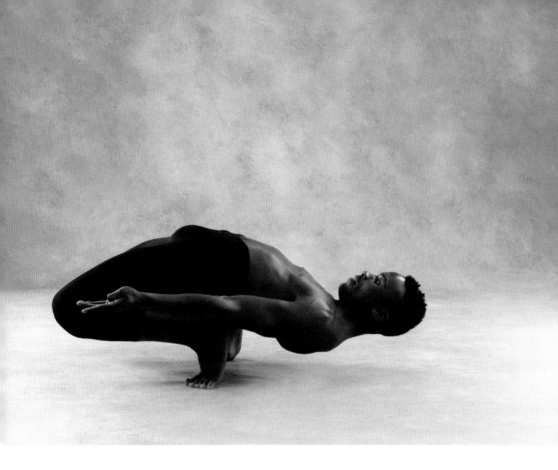

Situations Determine Your Choices

The situation you are working in will determine the best type of lighting. Lighting for a dance school can be very different from what you might choose when working with a more advanced or professional dancer. With either, you will usually be working with strobes, more commonly referred to as flash. While you can make just about anything work, speed lights are not going to be the best choice. You will need to have 2–4 strobe heads and light modifiers or mono lights.

Flash and Flash Duration

Strobe units do not need to be expensive for most dance situations. Unless the dancer will be moving and jumping, you can treat it like most other portrait situations. If you want to stop movement, you will need to consider other options. The duration of a flash discharge defines the ability of the flash to capture or freeze the movement of the subject. If you are trying to photograph a dancer jumping or moving very fast and there is blur in the image, the issue is with the flash duration.

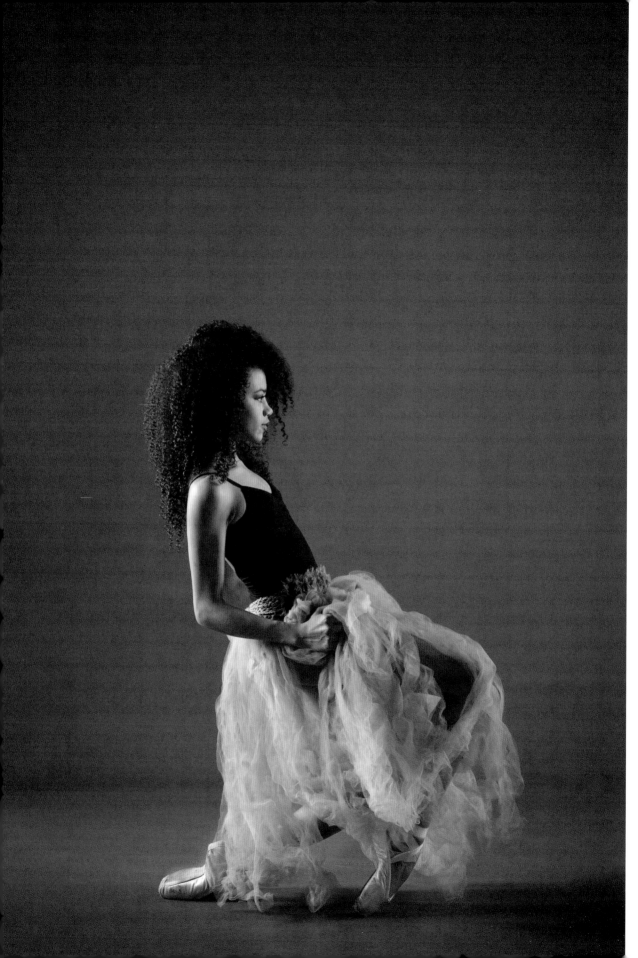

Light and Stopping Action

There are many manufacturers offering strobes that can freeze motion, however, they can be expensive. You will need to research different units and make the best decision for your needs. My choice is the Paul Buff Einsteins. They offer a lot of bang for your buck! It is a mono light that offers leading color temperature consistency and superior action-stopping capability.

A Complete Light Set

Most strobe units do not have the proper flash duration to stop the speed of a dancer jumping. If you want to do this kind of work, you will need to invest in at least two monolight units that have a fast duration. I prefer four but you can get away with two. Use one on the main light and one in a strip box. This will be enough to stop the motion in most cases. If you have four that's even better. A complete set will always produce the best result.

You will need to research different units and make the best decision for your needs.

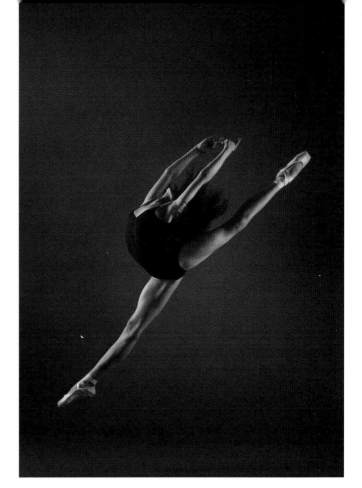

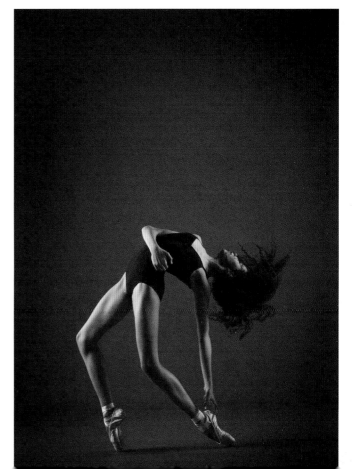

Number of Lighting Stations

When choosing lighting for dance schools, you will need to determine how many stations or set ups will be needed for the job. This is usually determined by the number of dancers you will be photographing. It is best if each station can have the same lighting setup, ensuring that the lighting is consistent for the entire job. You do not want to spend time color correcting and adjusting exposures after the fact.

Make Lighting Stations Identical

If you have multiple photographers, it is advantageous for them to be able to move from set to set without changing or adjusting their cameras. There are any number of reasons

you may need to move a photographer during a large dance school shoot. Making sure that every station is consistent will help keep post production time to a minimum.

Use Forgiving Lighting

When photographing a dance school your subject can range from the smallest ballerina to a high school senior. Your lighting needs to accommodate both groups without making many changes. Using what I refer to as a "forgiving lighting" situation will be the smartest choice.

There are many factors involved in the choices made for both your strobes and lighting modifiers. Since you will likely need multiple stations, cost will always be a factor. You will be pushing the lights to the limit on a large dance school and will need to choose dependable equipment.

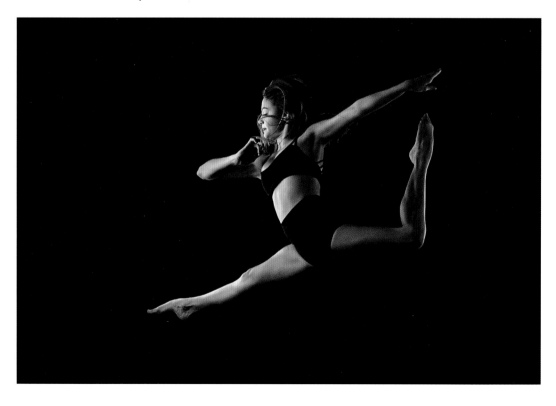

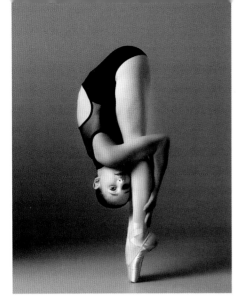
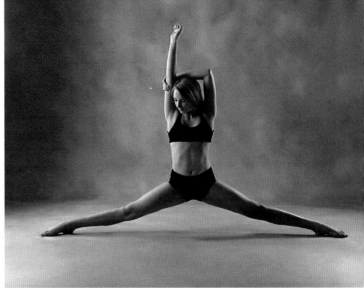

Start with One Lighting Kit

I use four Paul Buff AlienBees™ B400 Flash Unit mono lights at each station. Since I prefer to shoot at f/5.6, I don't need the higher power units. The AlienBees B400 is a powerful, self-contained studio flash unit with adjustable output from full power (160 Watts) down to $\frac{1}{32}^{nd}$ of the total power. If you like to shoot at f/11, you may want to consider one of the higher power units. The lights are affordable enough that I can have the same light kit at every station. If you are just starting out, it may take you a while to have the equipment you feel you need. Start with one complete setup and build from there.

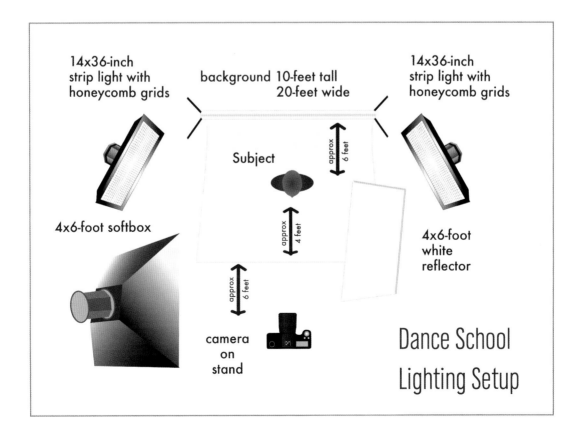

14x36-inch strip light with honeycomb grids

background 10-feet tall 20-feet wide

14x36-inch strip light with honeycomb grids

approx 6 feet

Subject

4x6-foot softbox

approx 4 feet

4x6-foot white reflector

approx 6 feet

camera on stand

Dance School Lighting Setup

Kits That Produce Studio Lighting

Each station has a collapsible 4x6-foot soft-box from Denny's Manufacturing and two large 14x60-inch strip boxes with honeycomb grids from Paul Buff. I use a hair light with

While it might be easier to blast flat lighting, it will never look as pretty.

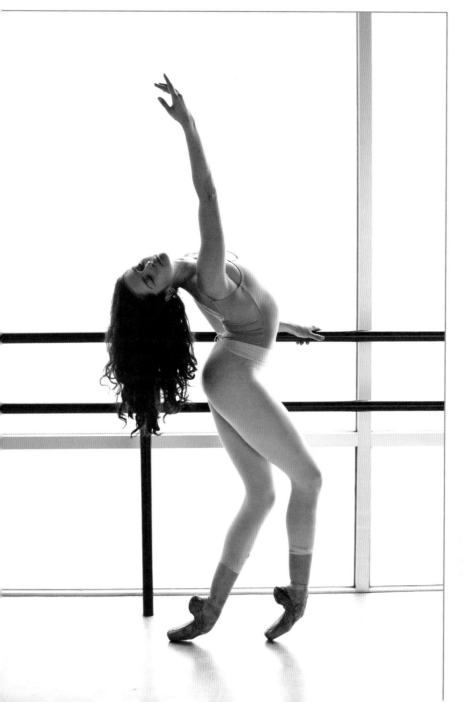

a 10x30-inch strip whenever possible. The ceiling height will determine if I use this light or not. I also have a large reflector across from the main light for fill. I basically shoot exactly as I would in a portrait studio setting. While it might be easier to blast flat lighting, it will never look as pretty. Parents do notice the difference and your sales will reflect this.

Many Good Lighting Choices

I choose these modifiers because they fold down like umbrellas and make for an easy set up and tear down. There are many other

great options out there. I use Larson softboxes in my studio and they are always my first choice, but they do not tear down as easily. For the dance schools, they are not as practical.

A Softbox with Reflector for Fill

I like using a 4x6-foot softbox for my main light. It is very forgiving. In a large dance school, you will have many very young dancers. A large light source will offer soft, beautiful light, while allowing for a bit more flexibility in the posing. I place a large reflector across from the main light to fill in shadows. This is needed with the young dancers, as they cannot always pose as easily. This adds a bit of flexibility.

At Times Use A Grid

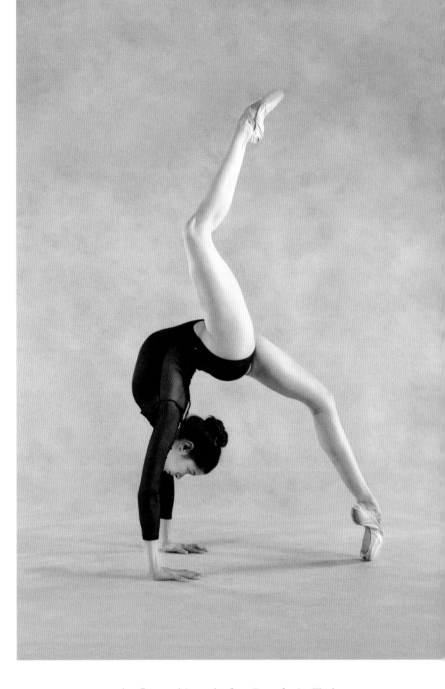

I like to use the honeycomb grids on a darker background to help control the spill, but sometimes on a lighter background, I may not use them. The light spill can help light the floor a bit and often I prefer it. To be truthful, I have done this for a while and can play with the lighting a bit.

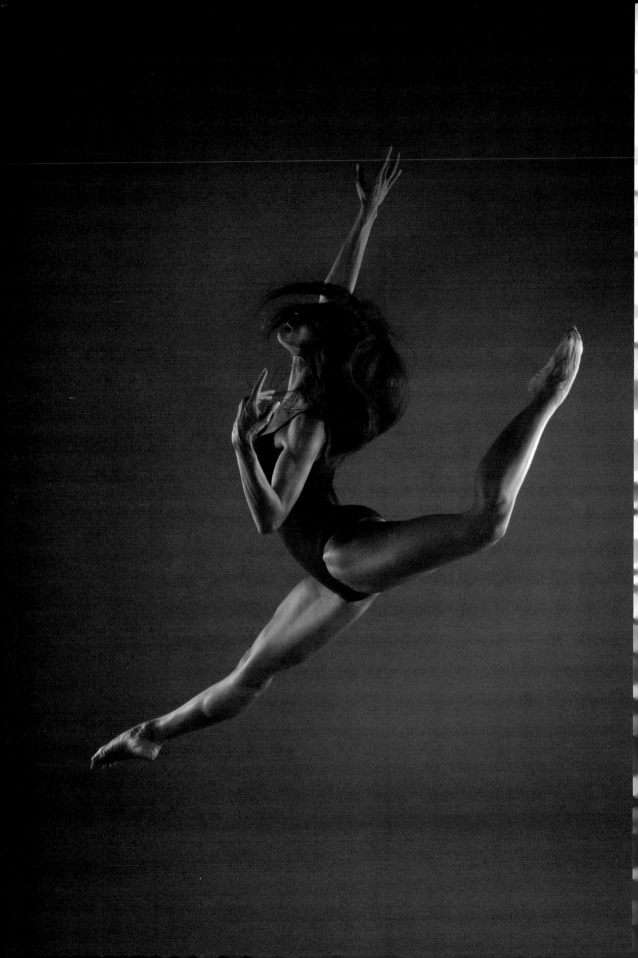

Dramatic Lighting

I love dramatic lighting and will use it—when ever possible. For more advanced dancers and professionals, changing up the lighting keeps things interesting and challenging. Using large strip boxes with grids gives you very directional lighting and, while beautiful, the dancer's position must be exactly right. I place these lights on each side of the dancer. This lighting works really well for a low-key dramatic look.

This beautiful dancer is the Mom of four. It had been years since she had been photographed, and she really pushed herself to have the confidence to do it. To say she is amazing is an understatement. She was such a pro that it made the session easy.

With Dramatic Lighting, Shoot RAW

I photograph everything RAW. The only time this changes is for a dance school. With dance schools, the lighting does not change and you are dealing with thousands of images. When photographing in dramatic lighting, shooting in RAW will give you many more options when processing your images.

Keep Dancers on the Background

Try to keep your dancers on your background. This seems obvious, but it is very easy in a session to assume you can fix it in post-production. Fixing this situation can be difficult and very time consuming.

When photographing in dramatic lighting, shooting in RAW will give you many more options when processing your images.

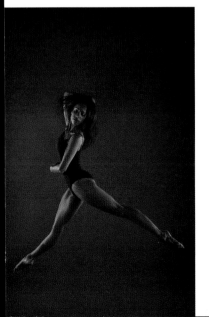
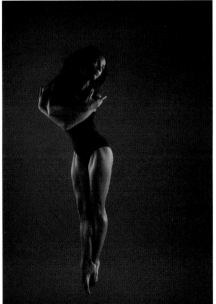
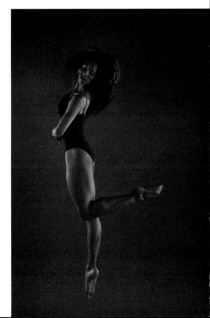

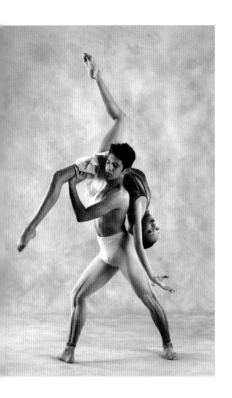

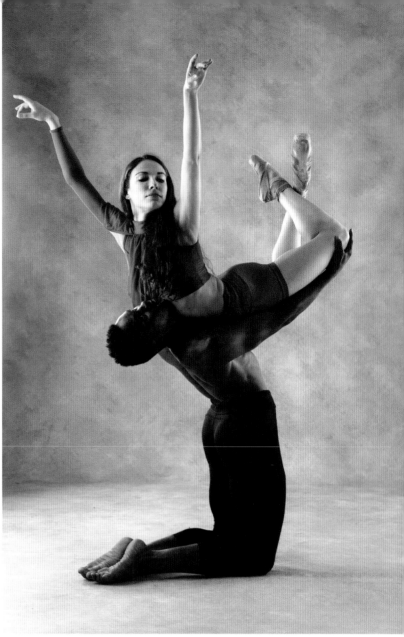

want to work with you. Dancers can always use new pictures and they love the creative process. Typically, they will be very happy to work with you in exchange for prints and images they can use for auditions and their websites.

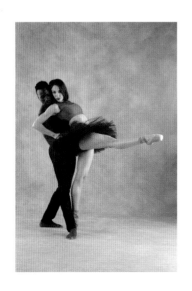

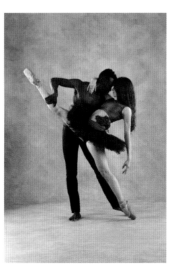

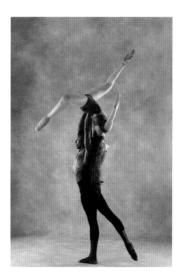

Collaboration and Beyond

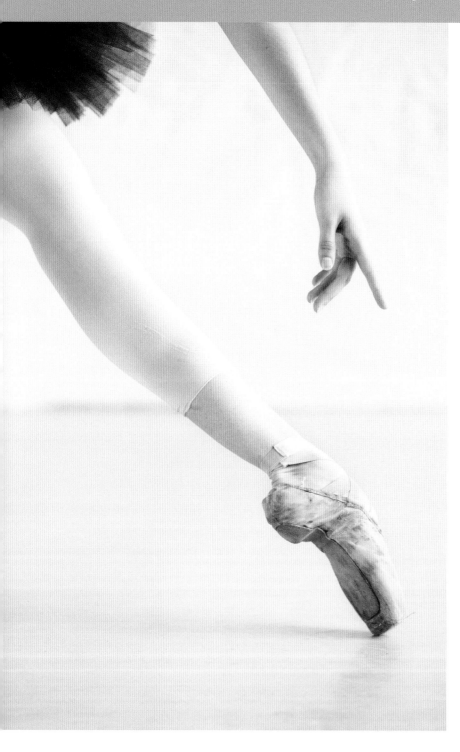

Document the Amazing

Heather has *the most* amazing feet. If you want to know what great feet look like, this is it! I always wanted to do some work like this and Heather was the perfect subject. I photographed her in natural light. The camera settings were f/1.2–2.8 with an ISO of 3200. The soft shallow depth of field was exactly the look I was going for.

These images are different from many of the others included in this book. Never be afraid to try something new. While this type of look would not work in a dance school situation, it is perfect for an advanced or professional dancer.

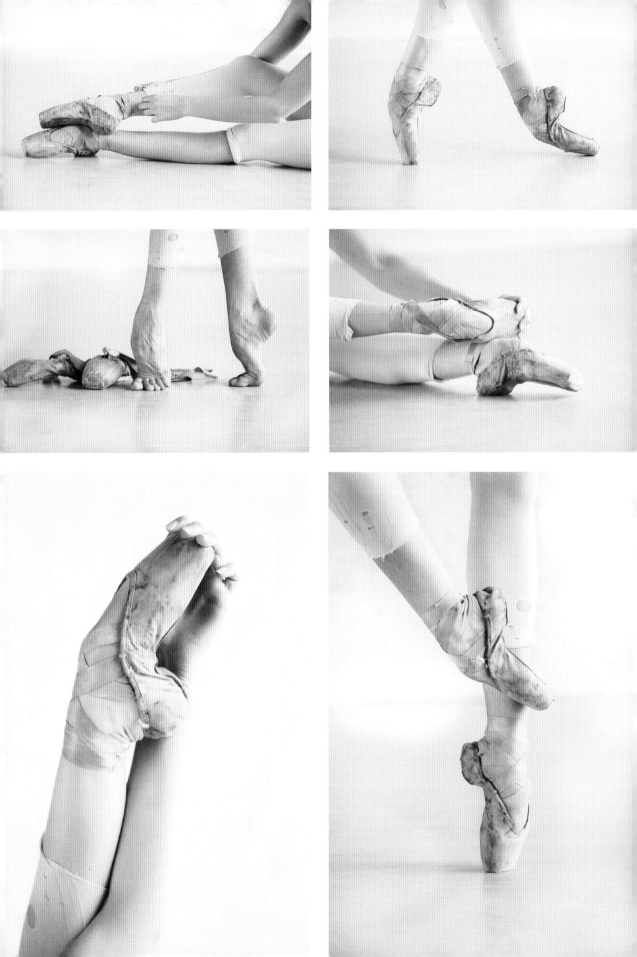

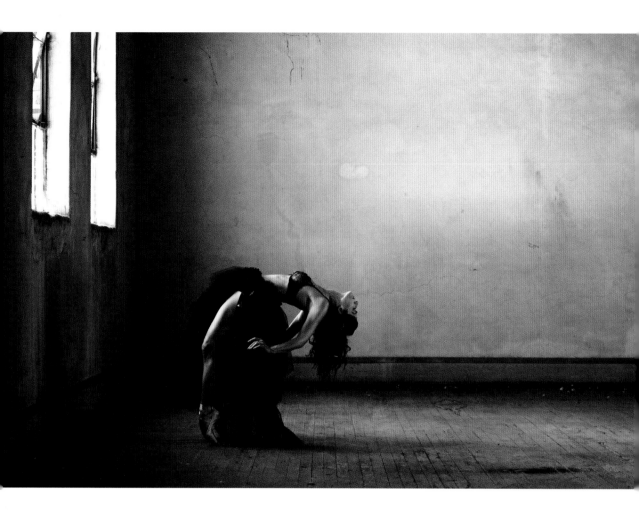

The Professional and the Creative

My good friend, Mayra, is a passionate and beautiful dancer. She now has her own dance company and has been a great source of encouragement and knowledge. She never runs out of creative ideas and is passionate about anything dance. Finding someone you can ask about dance terms and technique will be invaluable if you want to be the very best dance photographer you can be.

Try Different Lighting Techniques

In this session with Brianna, we wanted to capture something soft and elegant. We used both natural light and a constant hybrid lights by Sweetlight. The constant lights were a 4x6 softbox with two strip lights. The light is soft and different from what you would get using flash.

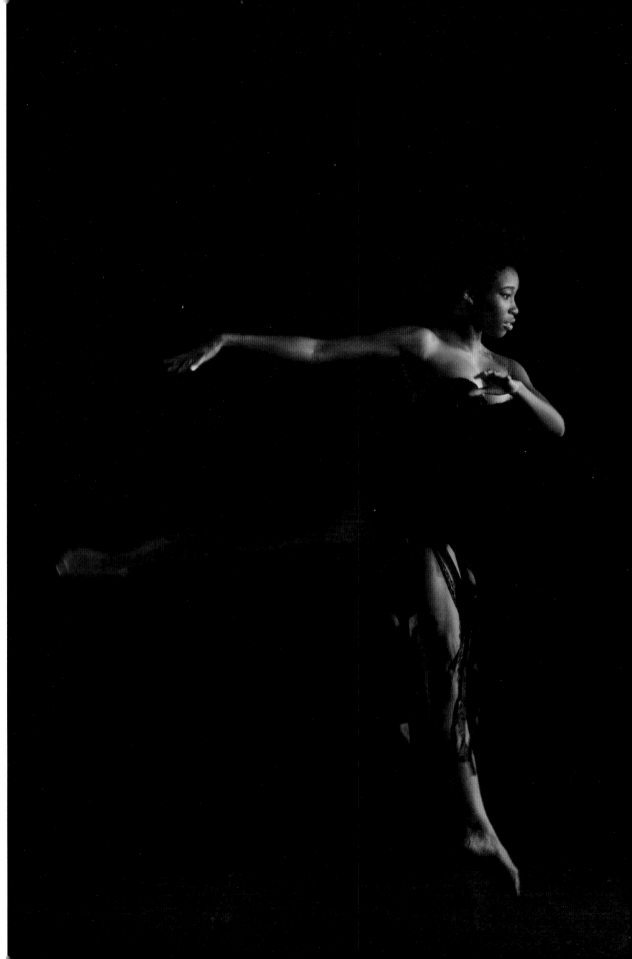

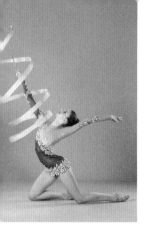
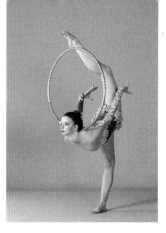
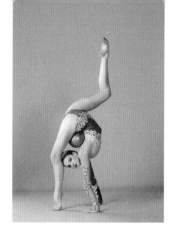
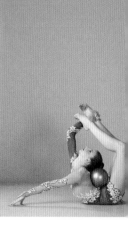

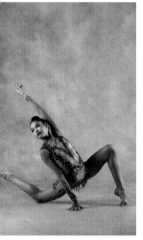
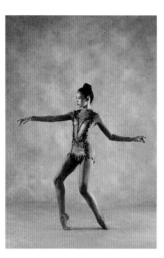
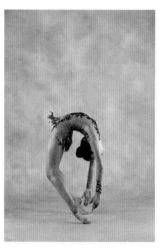
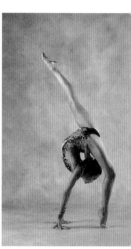

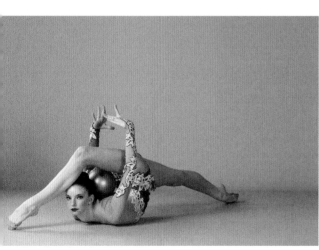

Consider Working with Gymnasts

When you work with dancers, you may also consider working with gymnasts or rhythmic gymnasts. Technically, you would photograph them the same as you would photograph a dancer. However, both sports have their own unique skills that you will want to familiarize yourself with. I find photographing gymnast challenging and exiting. The sports are beautiful to photograph and many gymnasts study ballet.

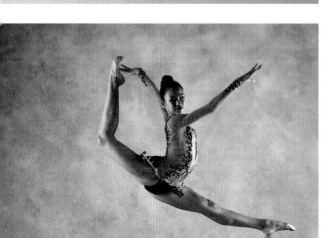

A Conversation

Have a conversation with your dancers. Find out what they are about. Ask questions and offer your stories:

- What do you like about dancing?

- Why do you want to dance?

- How does dancing make you feel?

Each one has something to say about their joy, hard work, history, culture, a unique view, or passion. Such a conversation can direct your artistic lens, enlighten their personal story to the viewer, and create amazing images.

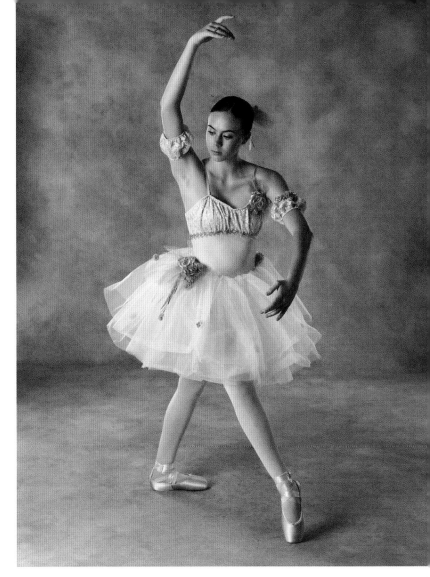

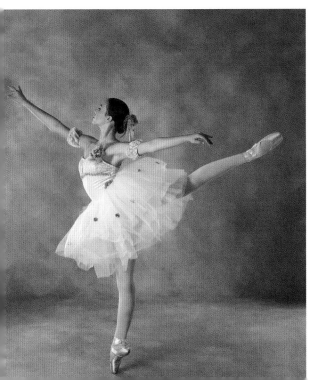

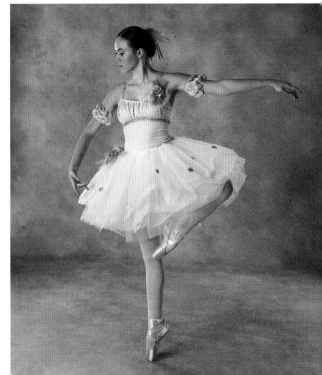

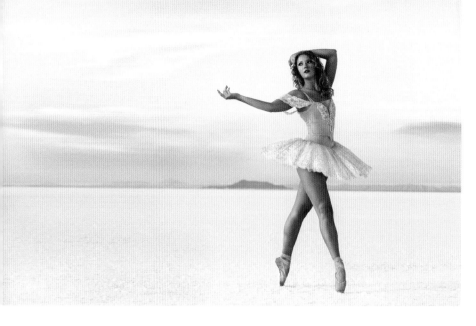

She knew exactly what I needed her to do. I was honored to include her in this book. She is the epitome of a dancer. As she shared pictures that appeared of her in LIFE magazine in the 1950s, I knew I was photographing dance royalty.

An Unusual Place: Salt Flats

I have always wanted to photograph at the salt flats outside of Salt Lake City. I finally got the opportunity and was thrilled to have Savannah agree to go with me. This was a tough shoot! The lighting was all over the place...no shade here! The salt was wet and got on everything. Every time Savannah moved, the salt flew. My friend, Drake Busath, lent me one of his photographers to assist and Savannah's dancer friend came to help out. It took all four of us to make this happen. It was a mess, but perseverance ruled the day! This image went loan on last year at PPA's IPPC competition.

Enduring Dance Vocation, Documented

Dancers never stop dancing. Dulce still teaches 10–12 classes a week. Born in Cuba, she left to travel the world as a professional ballerina. I photographed her in her studio.

The exciting part of working with dancers is that there is always something new to try, a cool new pose, or an amazing new camera. In the end these are the most important things:

• Know your camera! Know all of the settings in MANUAL and how changing them will affect your image.

• Learn how to take control of your session; direct and communicate with dancers to get the images you want.

• Master lighting that will work in whatever situation comes your way.

• Most importantly, have fun, get creative, and let your passion shine.

I am excited to share what I have learned in the last fifteen years about working with dancers. I hope that this information will help you grow as a photographer and create images that you can get really excited about.

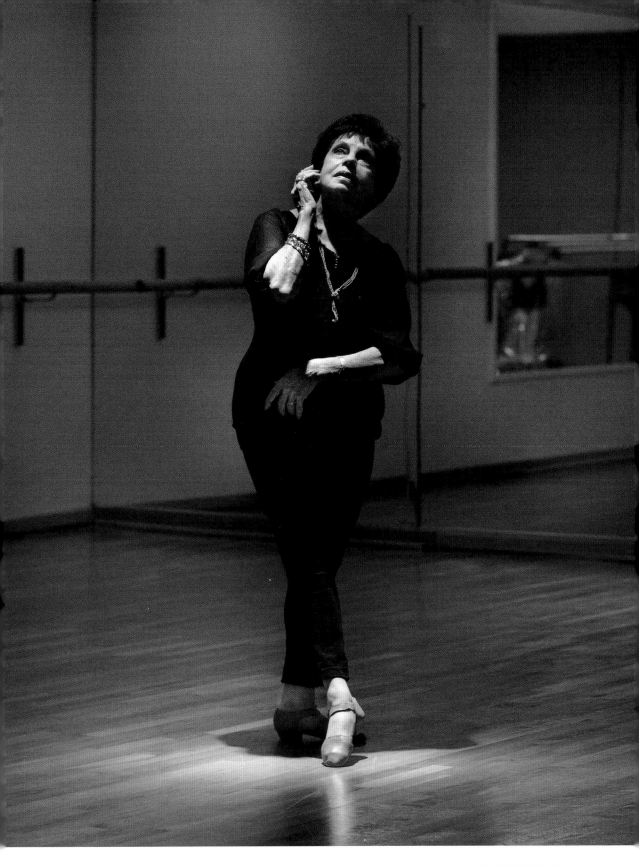

Thanks

Thanks—
Thank you to all of the amazing dancers. I have had the honor to photograph. You have been my inspiration. I am in awe of you!

Thank you to all of the professional dancers who were willing to create with me, and to the dance school instructors and owners who have respected me and allowed me to work with them. You have taught me all I know about working with dancers. I am deeply grateful to you for letting me be a part of your world.

Thanks to Carol, Ashley, and Heather for your hard work and dedication.

Thanks to Karen and Linda at Village Dance Center for believing in me all those years ago!

Love and thanks to the Ancelin girls—Jen, Audrey, and Ava—it started with you! Much love to Mary Speed! Dance on, girl! Thank you to Mayra for your love, support, and encouragement.

Index

B
Backdrops, 40, 64, 73, 87, 88
Basic positions, 23.
 See also Posing
Best sellers, 45
Body image issues, 105
Business opportunities, 10–11

C
Camera selection, 12
Clothing, 97, 106
Collaboration, 14, 24, 62–63,
 118–25
Comfort, dancer's, 35, 36,
 98–99, 123

D
Depth of field, 108
Directing dancers,
 15, 20–21, 26, 61–63, 97,
 100
Duration of shoot, 16–17

E
Endurance, 16–17
Expectations, 18, 21
Experience, dancer's,
 36, 43, 44
Experimentation, 28, 65, 111

F
Feet, 8, 23, 37, 90, 118–19
File format, 87
Flash duration, 75, 77
Floors, 73–74

G
Group portraits, 42, 112–17
Gymnastics, 11, 122

I
Image folder, 22
Instructors, working with,
 35, 46, 63

L
Leaps, photographing, 67–71
Lifts, 114–17
Lighting, 40, 75–87, 95, 100,
 107, 109, 113, 120
Live performances, 88–92
Location photography,
 88–92, 94, 124

M
Male dancers, 96–103
Monopods, 88
Motion, 33, 59–61, 66,
 67–71, 75, 77, 87, 109

N
Natural light, 109

O
Objectives, 26

P
Partners, 112–17
Posing, 15, 20–21, 23, 26, 28,
 31–34, 37, 48–58, 67–71,
 87, 88, 100, 114–17
Postproduction, 102

Props, adding, 40

R
Reflectors, 83

S
Safety, 74, 114–17
Schools, shooting for, 38–39,
 81
Senior dancers, 124–25
Senior portraits, 93–95
Shutter speed, 109
Silhouettes, 95
Softboxes, 83
Space, size of, 72–73
Special needs, kids, 56–58
Strengths, dancer's, 19, 66, 69

T
Terminology, dance,
 20, 22, 24
Timing, 68, 90, 92

U
Umbrellas, large, 87

V
Variety, increasing, 39

W
Weaknesses, dancer's, 19

Y
Young dancers, 45–58

Light and Shadow LIGHTING DESIGN FOR STUDIO PHOTOGRAPHY

Acclaimed photo-educator Tony Corbell shows you the secrets of designing dynamic portrait lighting in the studio. *$37.95 list, 7x10, 128p, 150 color images, index, order no. 2118.*

Master Low Light Photography

Heather Hummel takes a dusk-to-dawn tour of photo techniques and shows how to make natural scenes come to life. *$37.95 list, 7x10, 128p, 180 color images, index, order no. 2095.*

Storytelling Portrait Photography

Paula Ferrazzi-Swift helps you create more evocative images of children and families with these simple techniques. *$37.95 list, 7x10, 128p, 180 color images, index, order no. 2120.*

Senior Style

Tim Schooler is well-known for his fashion-forward senior portraits. In this book, he walks you through his approach to lighting, posing, and more. *$37.95 list, 7.5x10, 128p, 220 color images, index, order no. 2089.*

The Shadow Effect

Internationally acclaimed photographer David Beckstead shows how shadows can become a truly intriguing device for photographers. *$37.95 list, 7x10, 128p, 180 color images, index, order no. 2113.*

Shot in the Dark

Brett Florens tackles low light photography, showing you how to create amazing portrait and wedding images in challenging conditions. *$29.95 list, 7x10, 128p, 180 color images, index, order no. 2086.*

Photographing Headshots

Gary Hughes explores the process of designing attention-getting headshots that are perfectly suited to your client and their end use for the images. *$37.95 list, 7x10, 128p, 180 color images, index, order no. 2105.*

On-Camera Flash FOR WEDDING AND PORTRAIT PHOTOGRAPHY, 2ND ED.

Neil van Niekerk's new edition includes updated ideas for great on-camera flash lighting—anywhere. *$34.95 list, 7x10, 128p, 220 color images, index, order no. 2071.*

Photography: The Art of Deception

Irakly Shanidze explores the way that photographers use visual trickery to boost emotion and engage viewers. *$37.95 list, 7x10, 128p, 200 color images, index, order no. 2106.*

Portraiture Unleashed

Travis Gadsby pushes portraiture in exciting new directions with design concepts that are sure to thrill viewers—and clients! *$34.95 list, 7.5x10, 128p, 200 color images, order no. 2065.*